100
CHEEKS
KAVA
GORNA

It was Kava who told me to buy a pair of vintage Levi's. They were my first. *Make sure you get them tight,* she said, over and over again, as if worried I might forget. I later learned, after trying on stacks upon stacks of blue jeans at Grand Street Bakery, that you want your Levi's so snug you have to pull them over your body like a second skin and peel them off like the rind of an orange. That the denim should ride up your waist when you walk. It should rub your cunt when you sit down in a chair, stirring a faint reminder of sex, press up against the cheeks of your ass, cupping it, the line of your underwear always slightly visible. Either the waistline will push against your stomach, creating a slight bulge, like it does for me and my little belly, or it'll sit taut across, but either way, on the small of your back, there will always be a divot of space between fabric and skin where your waist widens into your torso. Eventually, your jeans will stretch out, so you won't have to hold your breath as you button the waist or suck in as you pull the zipper up your crotch. The denim submits to you, becoming an article of clothing totally and utterly devoted to you, shaped to match the contours of your body and your body alone.

I hadn't ever worn vintage denim before. It was insecurity that held me back. I assumed that the 501s and 505s and 701s of the world were built for bodies that weren't mine: wasp-waisted, amply endowed women who were courageous and uninhibited. But that was naïve and lazy of me to believe. I forgot the basic principle in fashion, which is that clothes are transformative. Who you are before and after wearing an article of clothing is exactly why you need to try it on. If it fits, the only thing that prevents you from wearing it is confidence. When I wore my Levi's, I became, in my own way, the woman I'd imagined too.

Denim was something of an accident. In the eighteenth century, an attempt to copy an Italian fabric called "serge" in Nîmes, France resulted in what people began to call "serge de Nîmes," which eventually was shortened to "denim." Blue jeans came later, in the American West, in the middle of the nineteenth century. A Bavarian immigrant named Levi Strauss imported the fabric—woven cotton dyed blue with indigo—from Europe and began selling it out of San Francisco as a durable alternative for men whose regular trousers couldn't last more than a fortnight. They were popular with the cowboys, prospectors and pioneers who chased the setting sun to the edge of the Pacific coast.

For a long time, jeans were only for hard labor and tough men, but in the last century, blue jeans, which had always symbolized freedom and adventure, began to be worn with new intentions. Sailors donned them on duty, popularizing the look. They were favored by polo players and became the uniform of choice on dude ranches as a kind of outdoor leisurewear for both men and women. Movie stars made them look good: James Dean, Marlon Brando, and Marilyn Monroe all wore denim for iconic roles on the big screen. Musicians, of course, wore the pants too—from Elvis to Bob Dylan to Bon Jovi. They were cool, but also subversive: favored by beatniks and punks, feminists and anti-war protesters, blue jeans became a symbol of the anti-establishment, a fuck you to the conventions of suits and skirts.

The jeans I found were made for a man, but there's a tribe of women these days who enjoy how the cut hugs their body. It's not only the feel of the fabric, which is stiff from the thick threads of cotton and flexible with age. Vintage jeans possess a particular color blue. I'm generalizing—it depends on the wash, of course, and the quality of the fabric. You can find whatever shade of blue you covet if you look long and hard enough. But you know the faded blue I'm talking about, don't you? It's a blue mixed with gray, like the color of the sky on a foggy day in San Francisco, the color that the coat of feathers on a pigeon can look in the late autumn light of New York. It's a blue that works well with everything. I wear mine with a pressed white-collared shirt and red lips. With tweed and loafers. Under a red-and-gold brocade dress. I always feel the most American in them, tough and understated. It's difficult to imagine any other item in my closet that is so ubiquitous, and yet, no one pair is ever the same after they've been worn in and washed.

This book is several things. It's an homage to vintage denim. It's a collection of beautiful women—best friends, confidants, collaborators, and peers who are all part of Kava's world in one way or another. Some are Kava's closest, oldest friends. Others have drifted through her life and past her lens only on a handful of occasions. It's also a book about style. It's about how women choose to wear their vintage denim, how it empowers them, and how there's no one way you can put on your jeans.

Lastly, of course—and let's be very real—this is a book about butts. Beautiful butts. Butts large and small, but all of them are, as Kava and I took to saying with a little giggle as we looked through the proofs, epic booties.

Kava makes a point of meeting her subjects in their own space and photographing in a way that makes her subjects comfortable. She talks to you, she listens. She came to my apartment in Park Slope on an autumn afternoon. The leaves had already turned and blanketed the grassy slopes of Prospect Park. She made me walk across a path, lean against a tree, and stick out my ass. *Hike up your pants,* she told me, *really, really, really high.* It was terrific fun. I relished how sexy I felt, and how easy it felt. And as I've gotten to know Kava, I've noticed this: she has her own way of organizing the world, her own internal logic that cannot be taught or explained. When you see her photographs, you begin to understand how Kava works. She's attracted to beauty, like so many people in art and fashion—she's drawn toward how it can be both strange and intoxicating, unadorned but not necessarily unguarded. She shoots women who are free and uninhibited, who aren't always interested in convention and the comforts that it brings. She's shooting the kind of woman we all believe ourselves to be.

Thessaly La Force

I have been thinking about 100 Cheeks for the past five years. The idea kept creeping up on me until I realized that I had to put all the pictures I was already taking in the same place and make this collection official. Whether I was shooting close friends or strangers with whom I would engage, I was constantly drawn to the way women identified themselves and represented their personality through the uniform of denim.

Initially, I tried to approach the subject of shooting girls' booties almost scientifically, with each shot from a similar angle and crop. I asked the girls to wear jeans because I found that nearly every girl had a pair she loved, which made her butt look great and which were personalized through their wear over time. I started to understand these portraits as a catalog of how women's bodies and styles vary even in the standard jean.

What I found inspiring about the jeans is that they were basically designed with the male figure in mind and created in a very functional workwear style, yet they were being appropriated by women in deeply individual ways. Each girl I photographed had an unmistakable and unique sense of confidence when wearing theirs. Each pair has been given a lot of love. They are made from a fabric that has a distinct way of forming to the body, and each tells a story through the way they are altered, worn out, and patched up. Some of them, you'll see in the photos, are like emblems of survival, proudly bearing either super shredded tears or extreme patches.

It's been inspiring to see women truly own their personal style, and divulge their view of what is sexy, through this originally for-male medium. 100 Cheeks *was* about which jeans a woman loves the most, the ones that frame her in the most pleasing way, but that meaning evolved over the process of editing this book. It grew into a representation of how we wear these jeans, which inherently carry a sense of defiance when you are a woman.

Kava Gorna

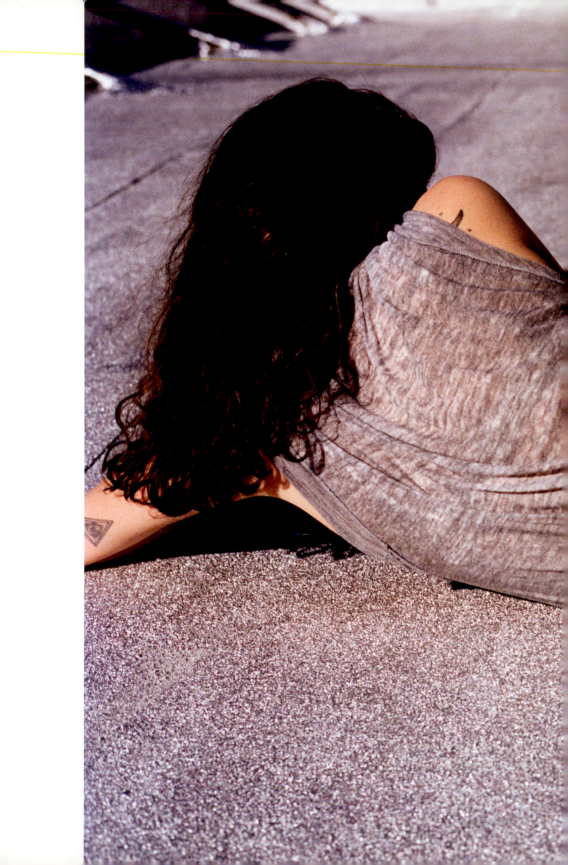

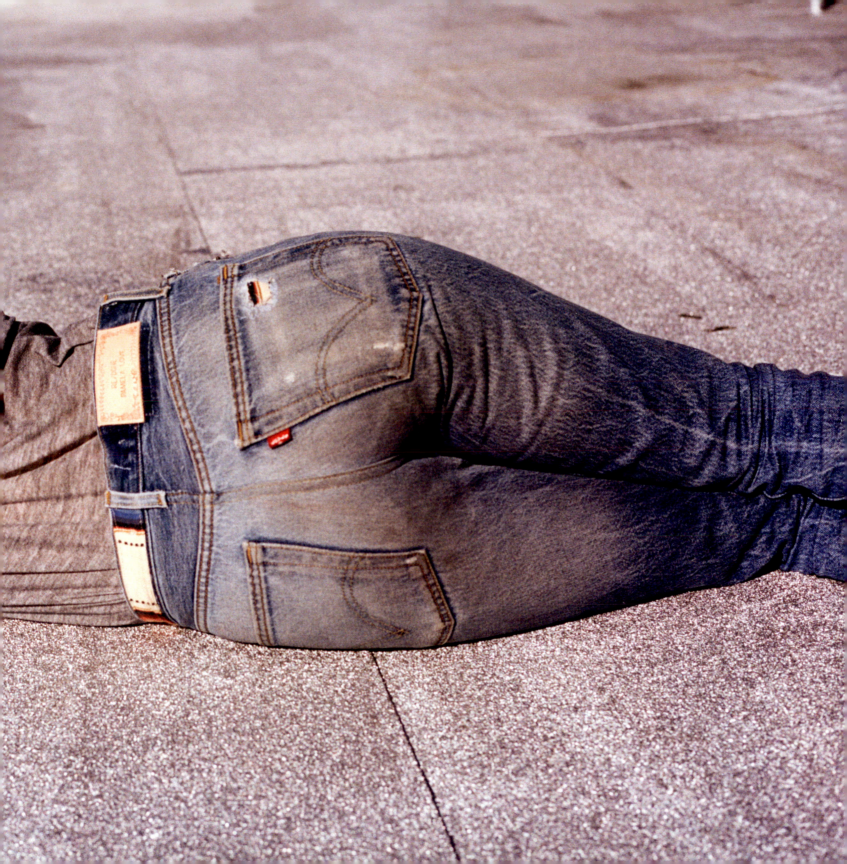

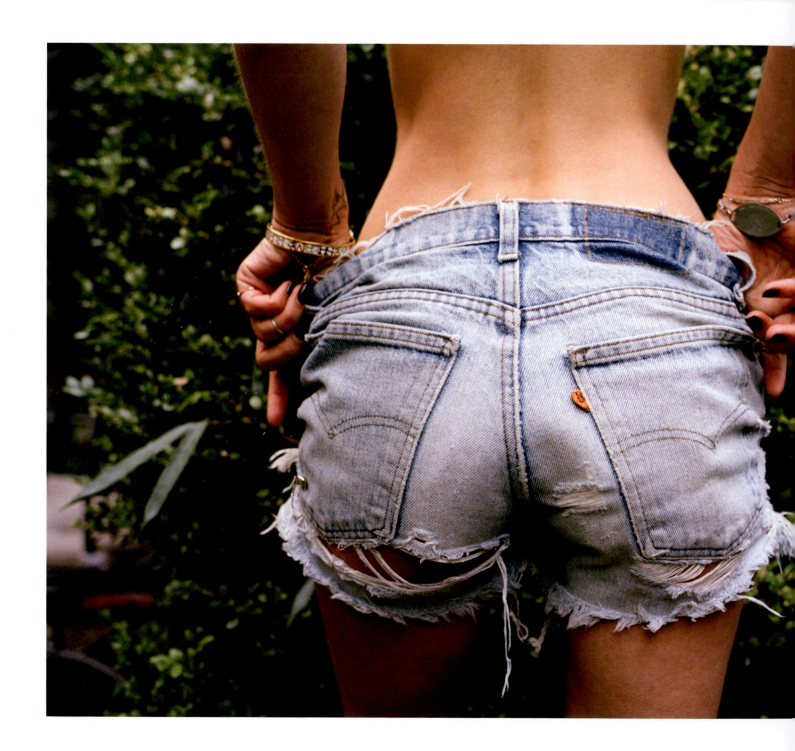

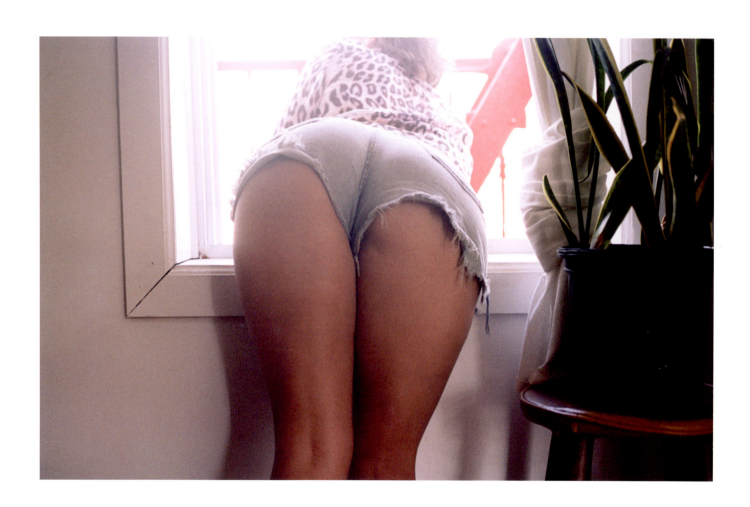

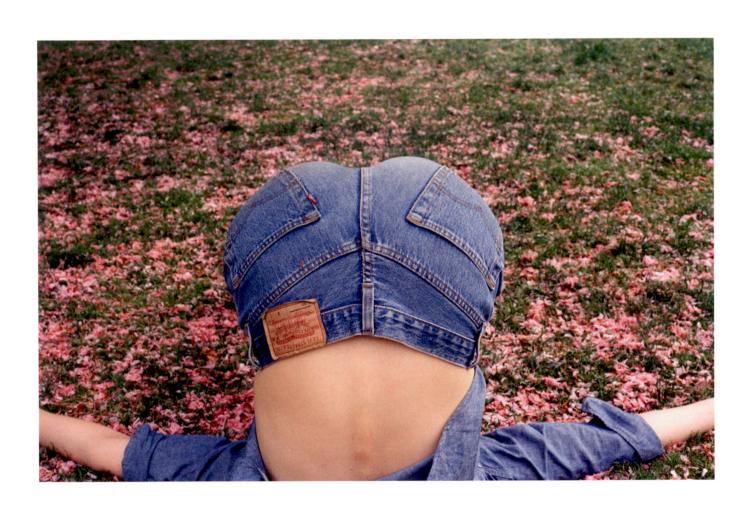

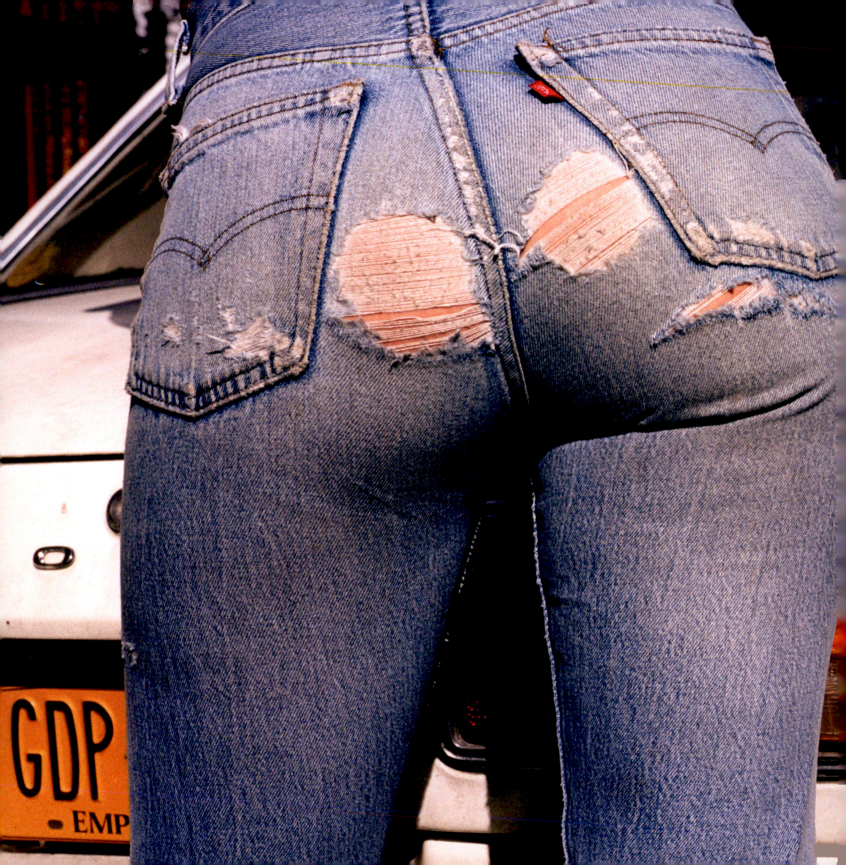

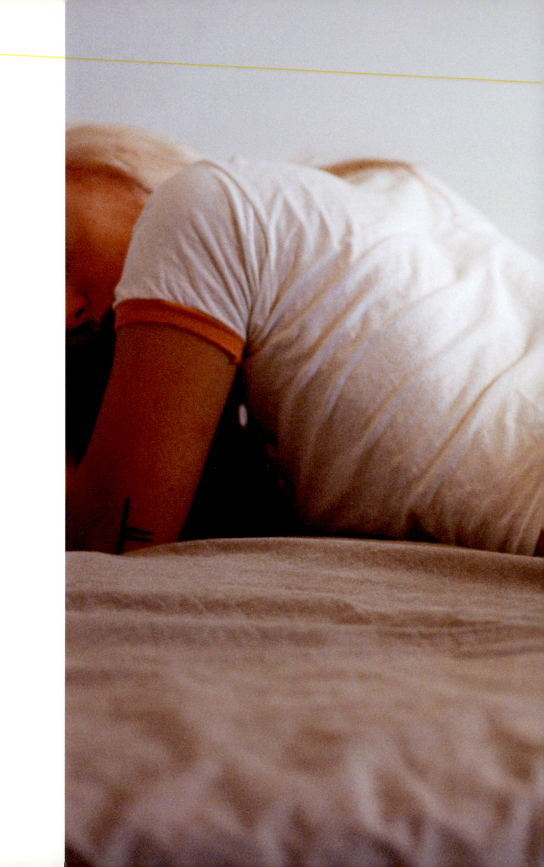

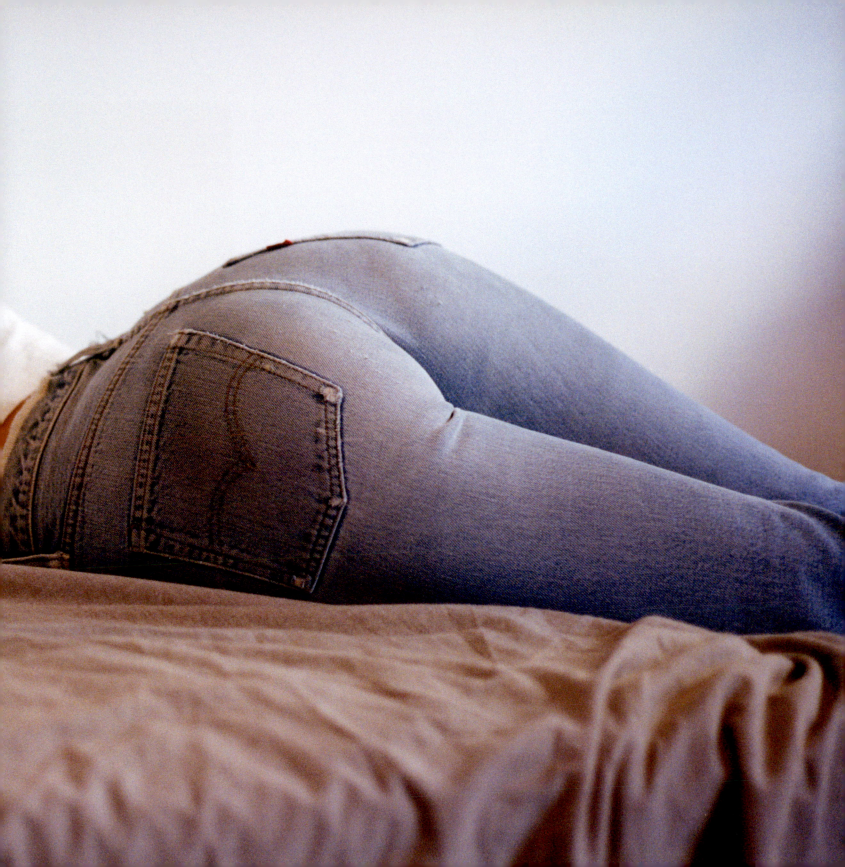

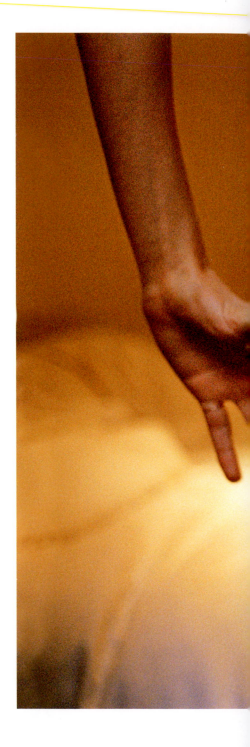

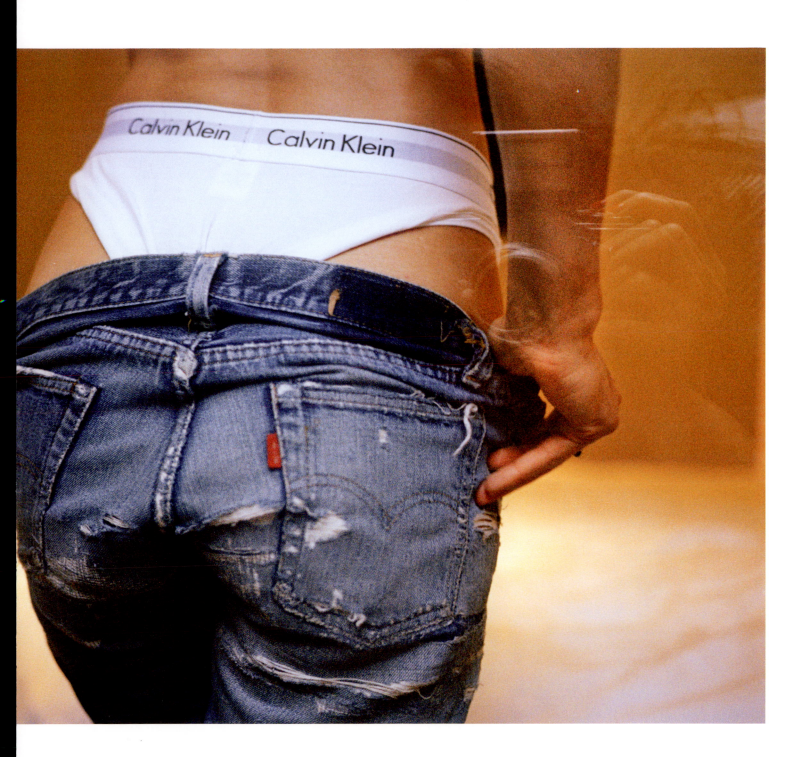

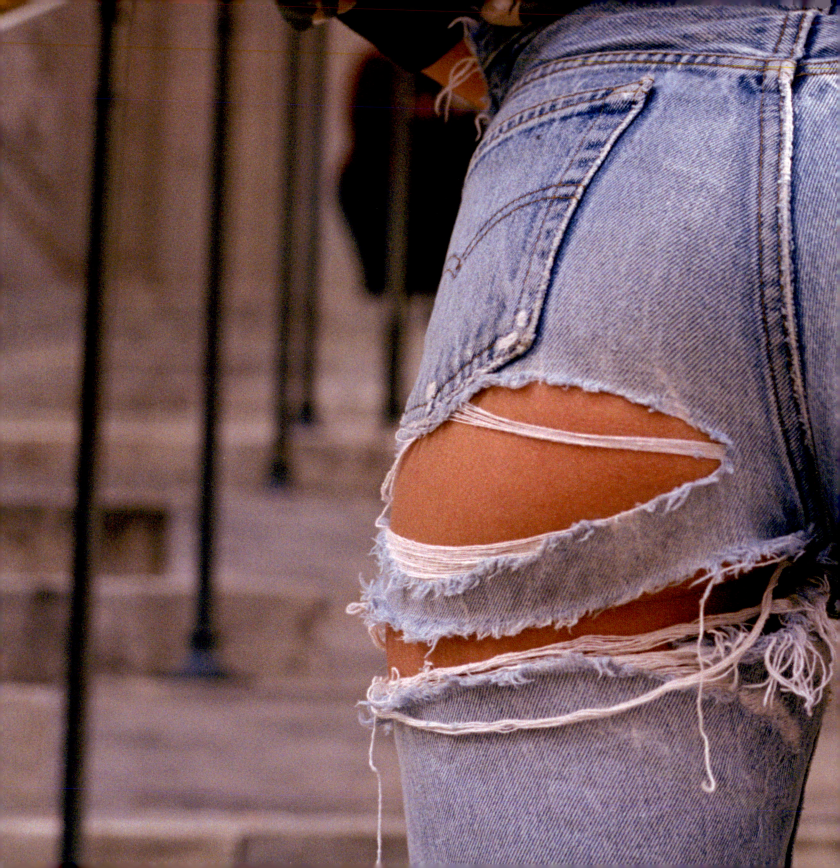

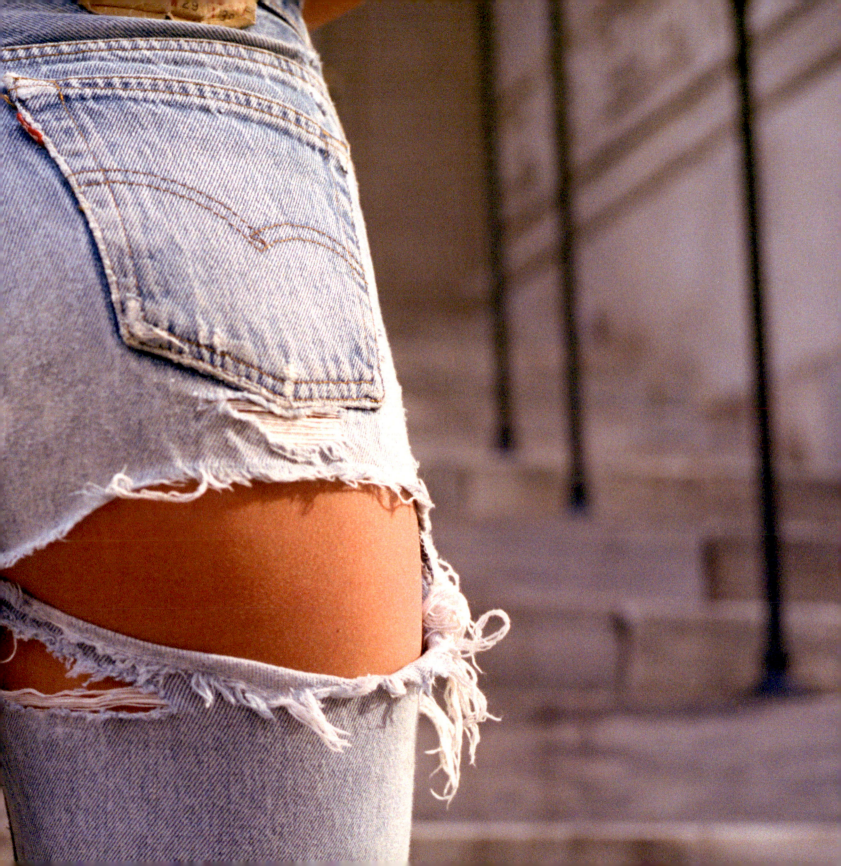

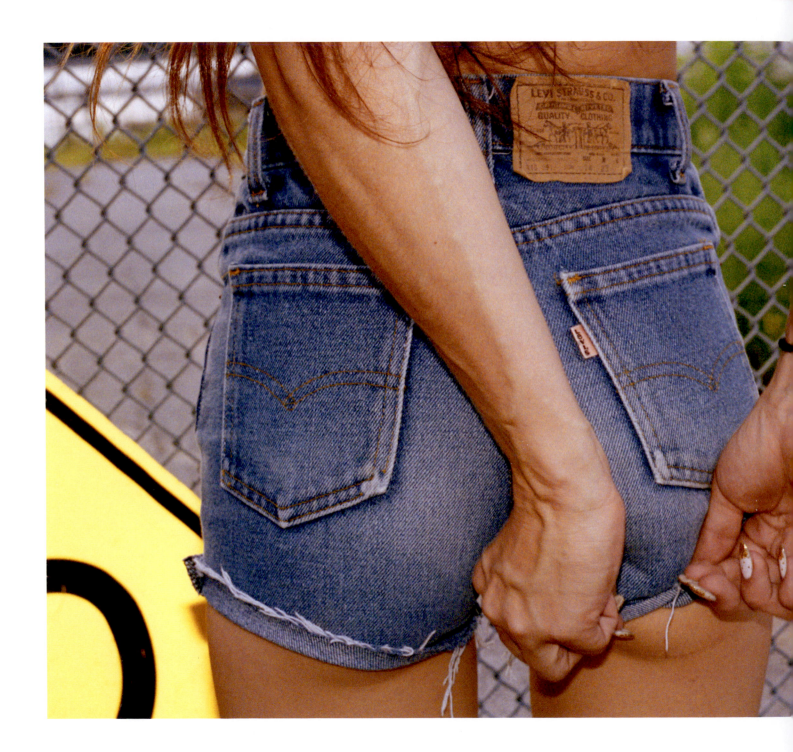

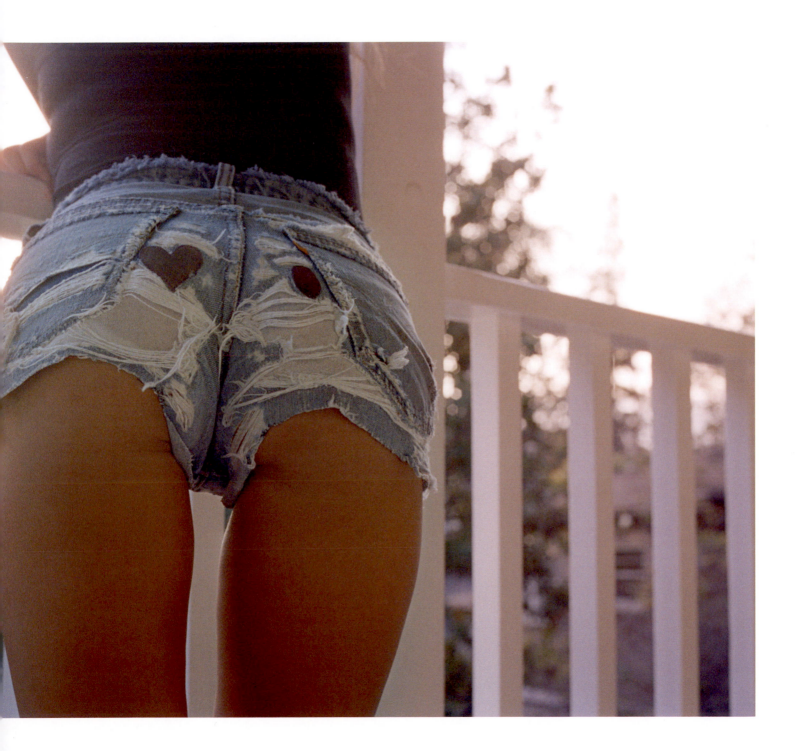

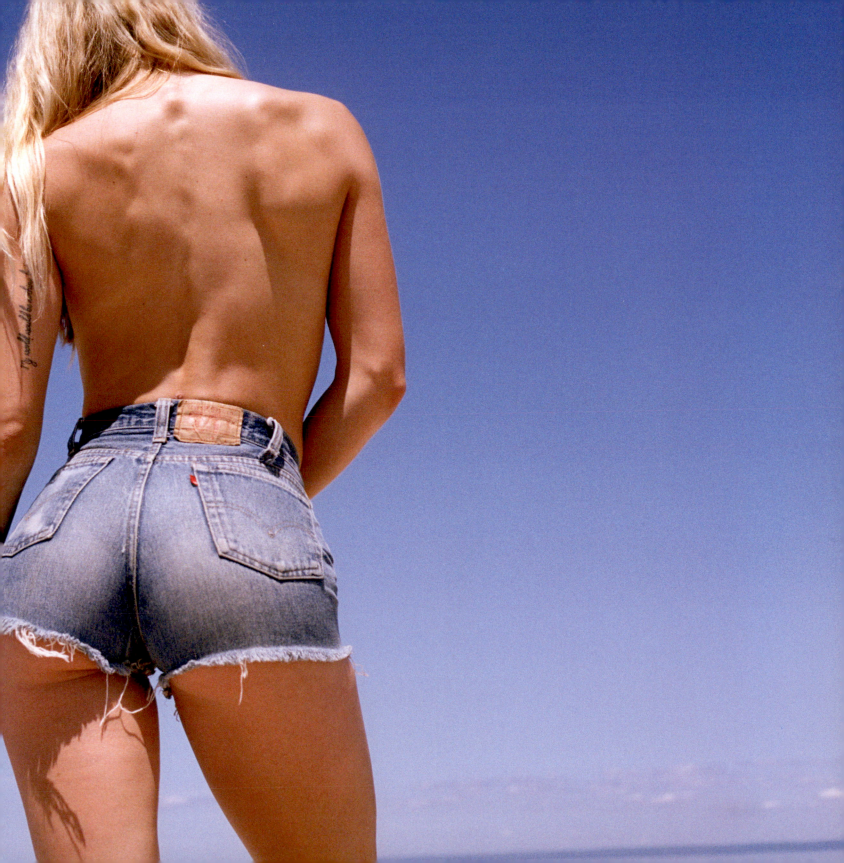

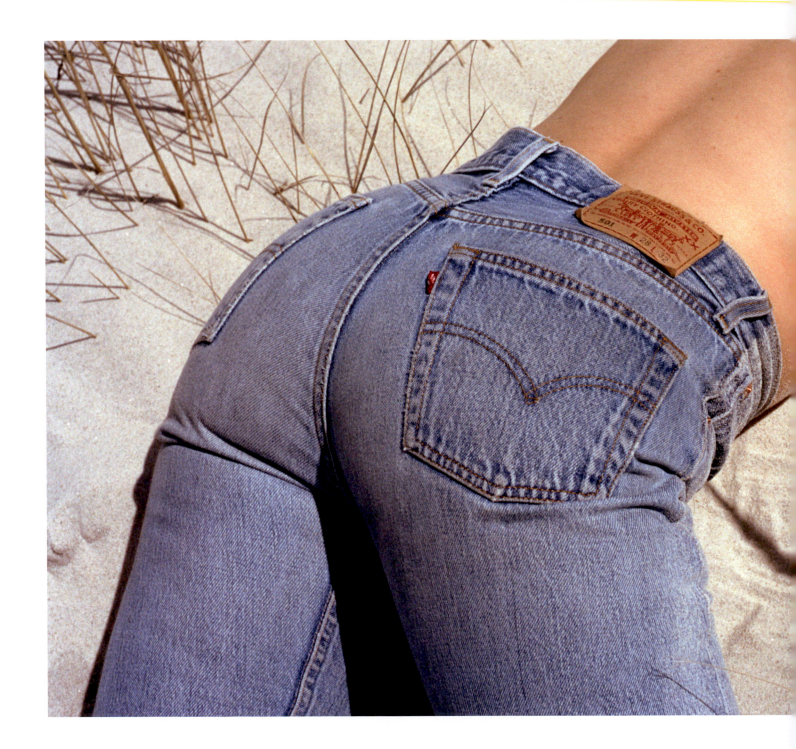

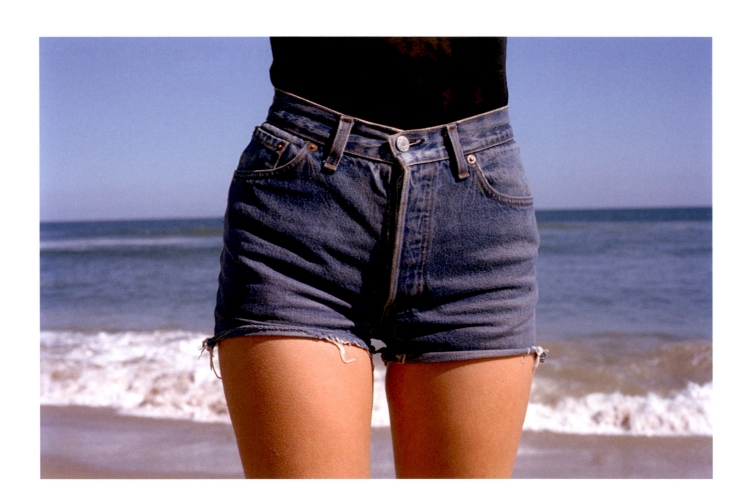

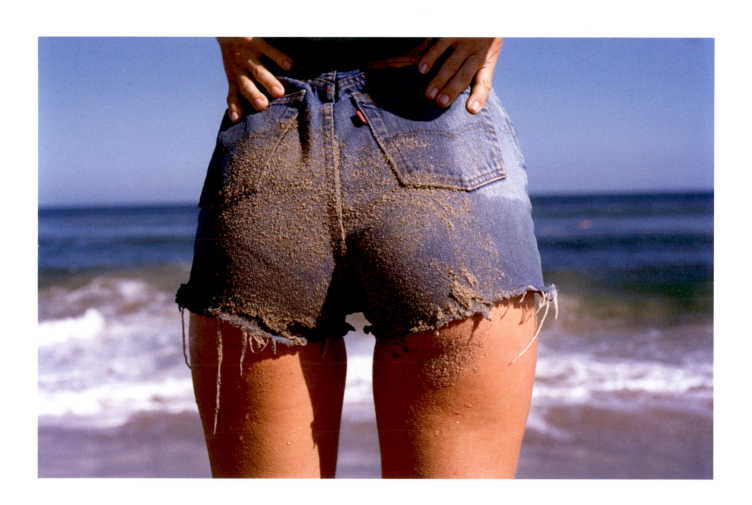

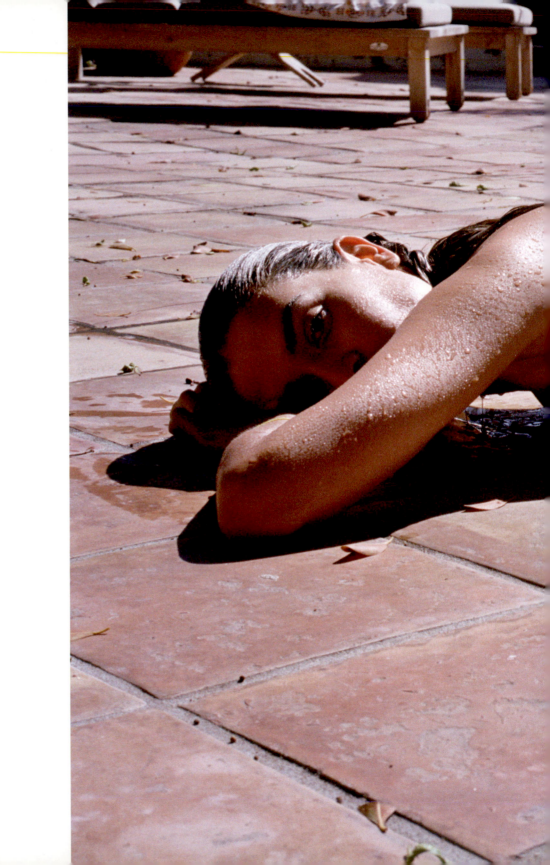

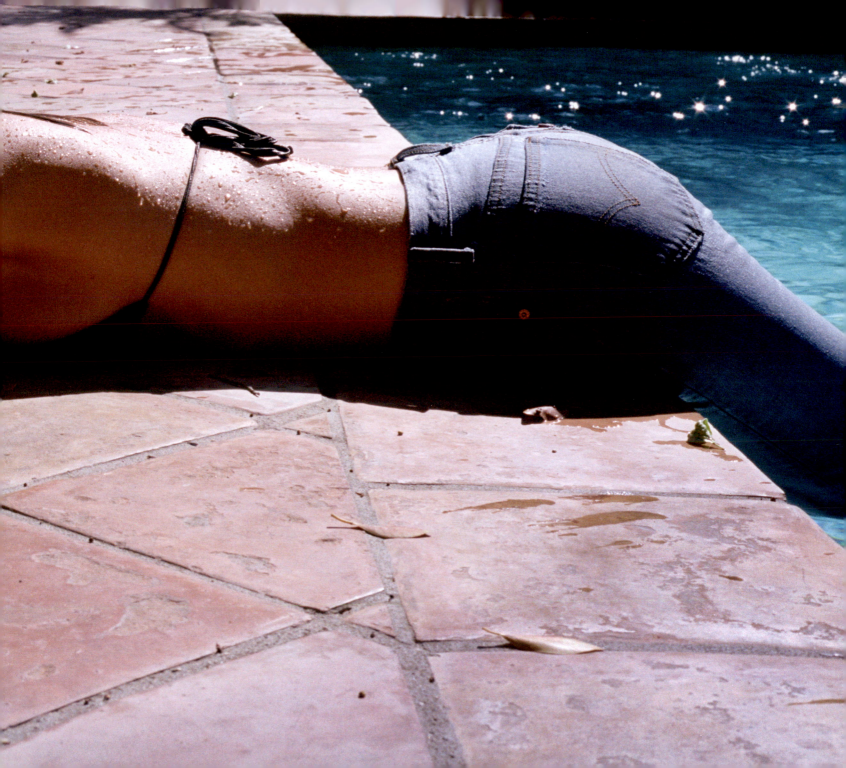

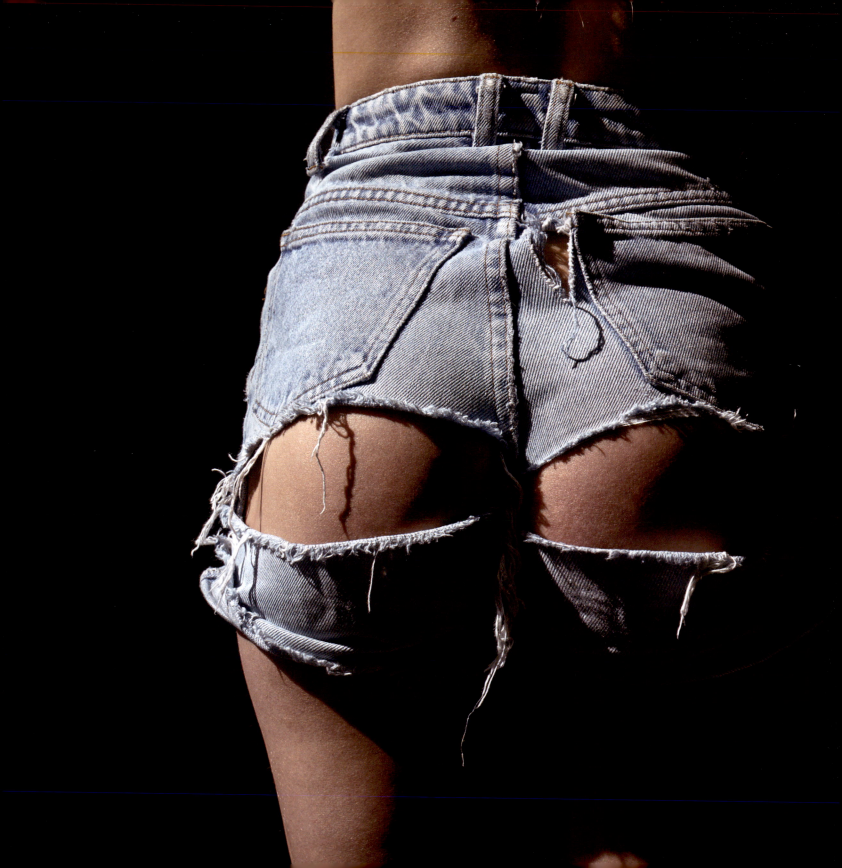

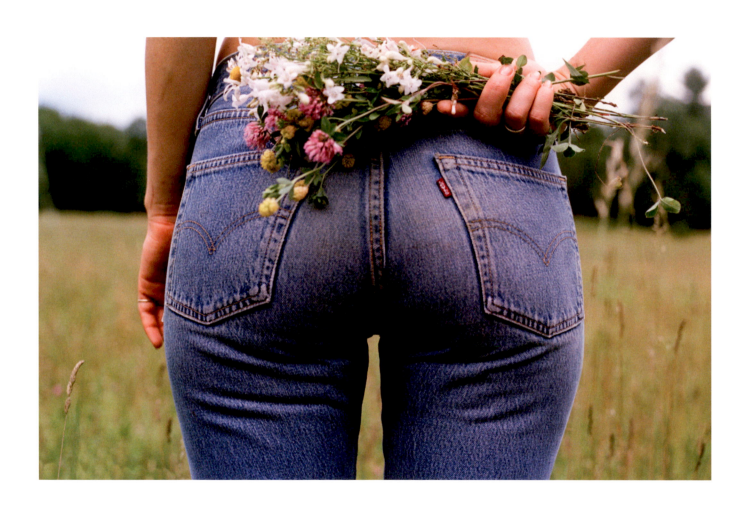

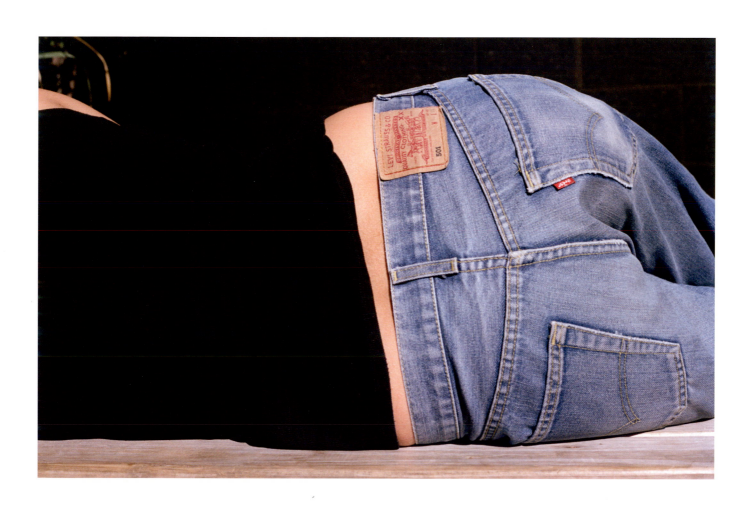

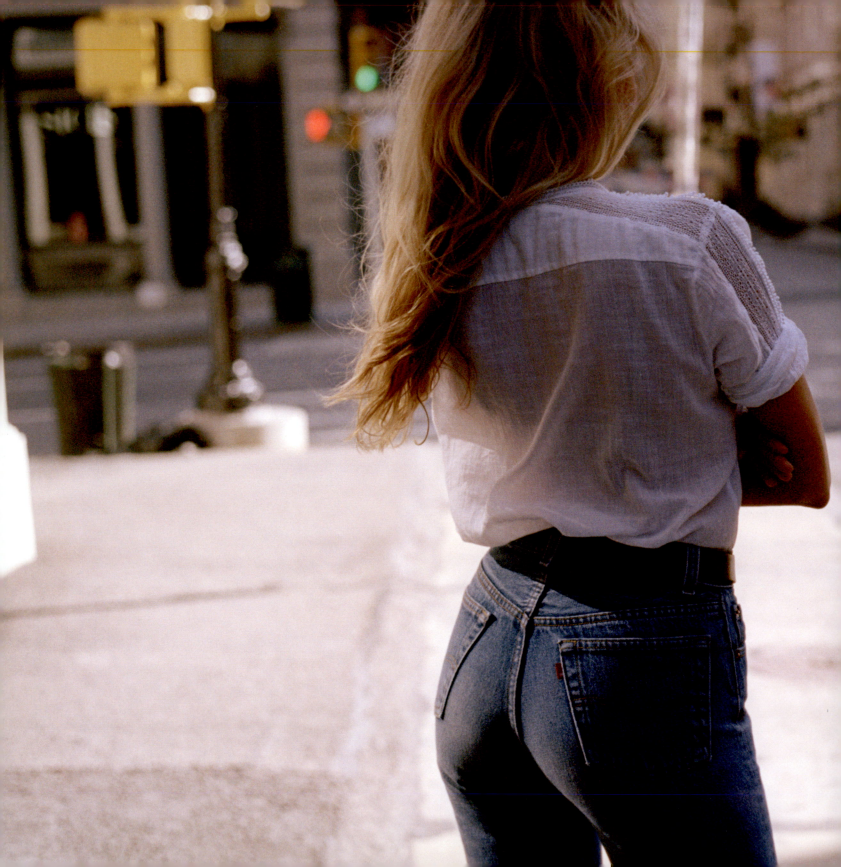

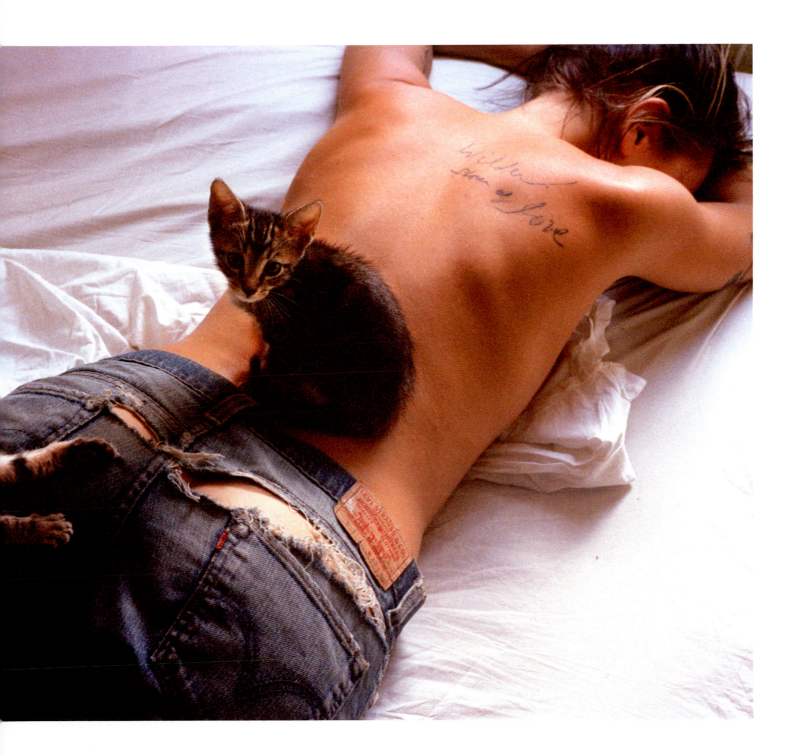

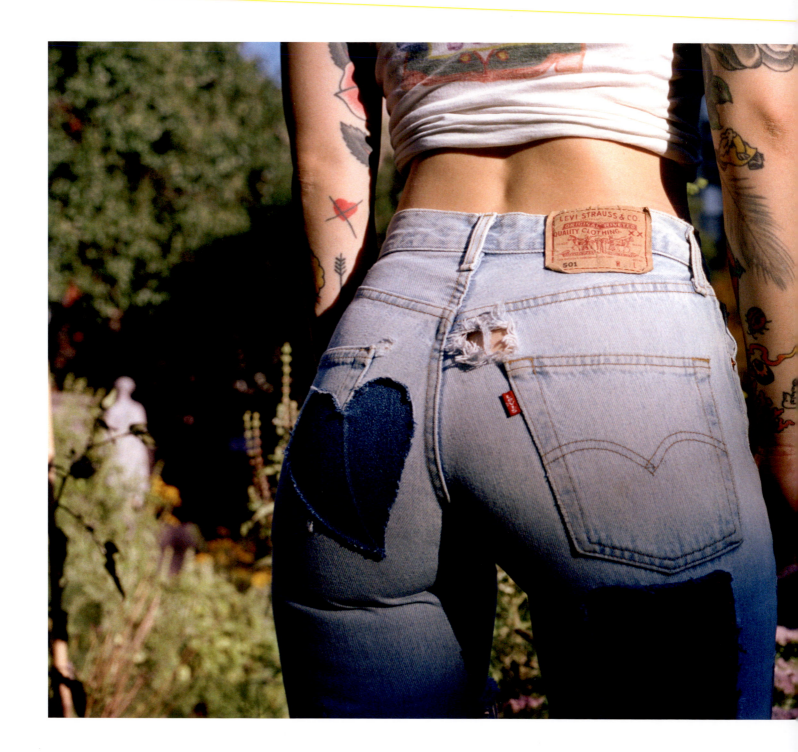

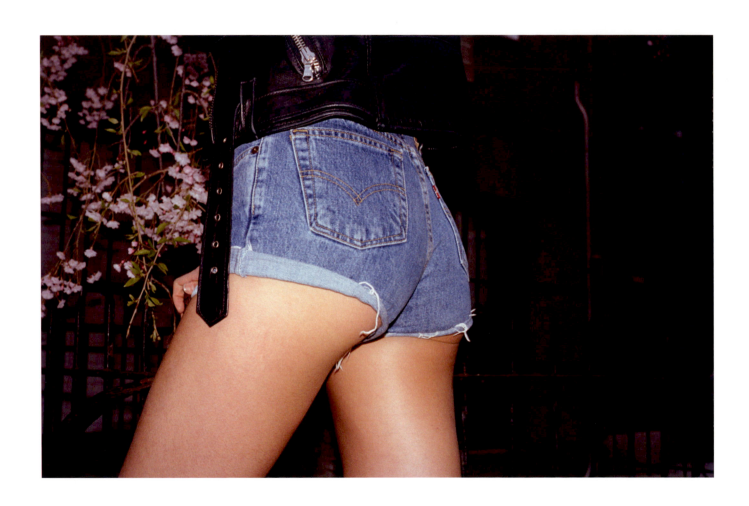

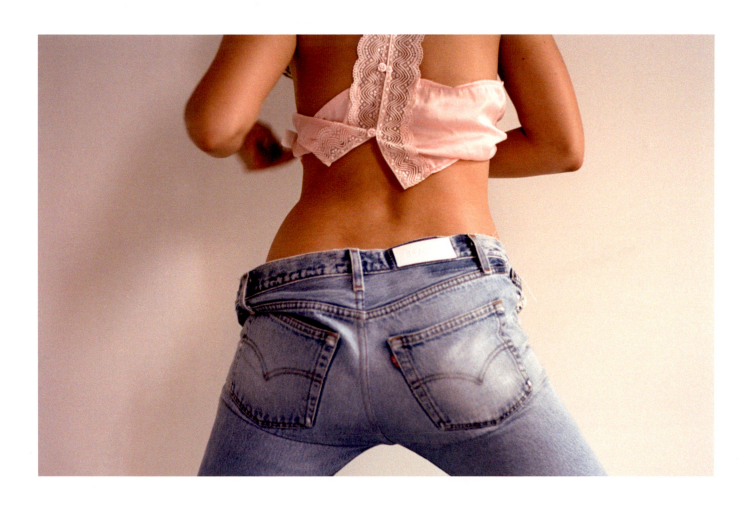

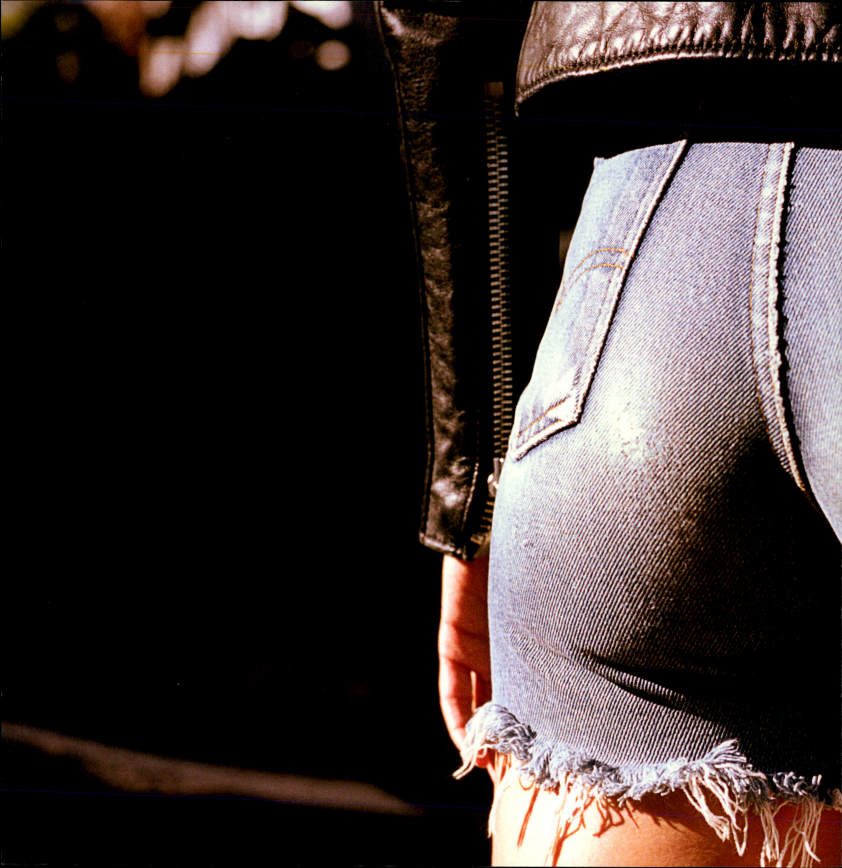

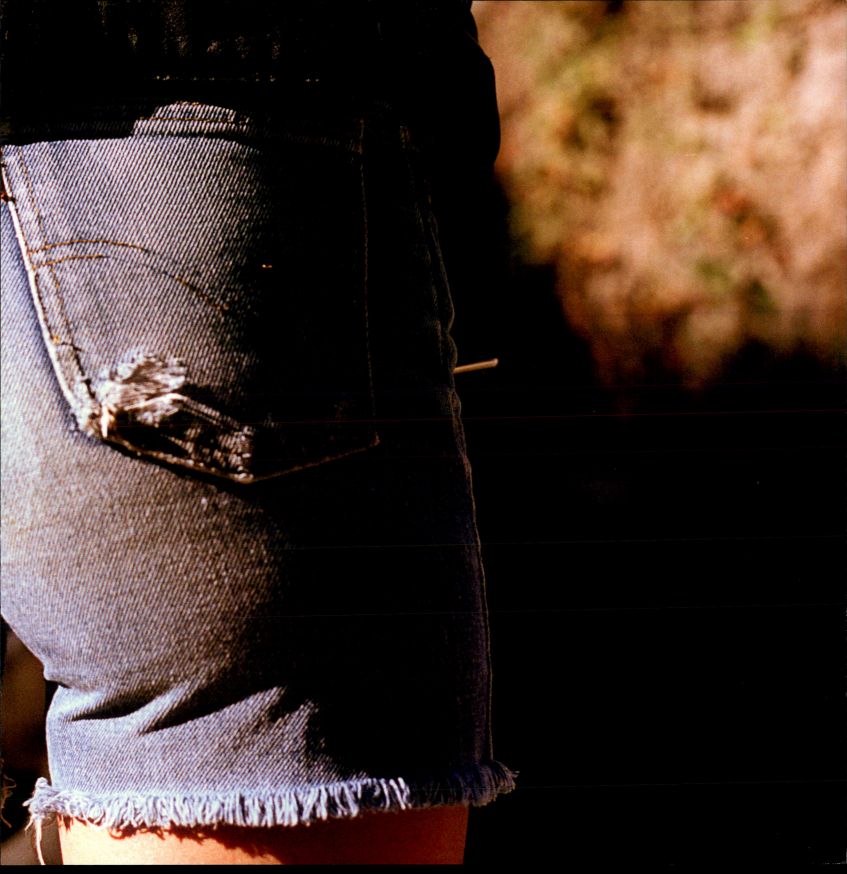

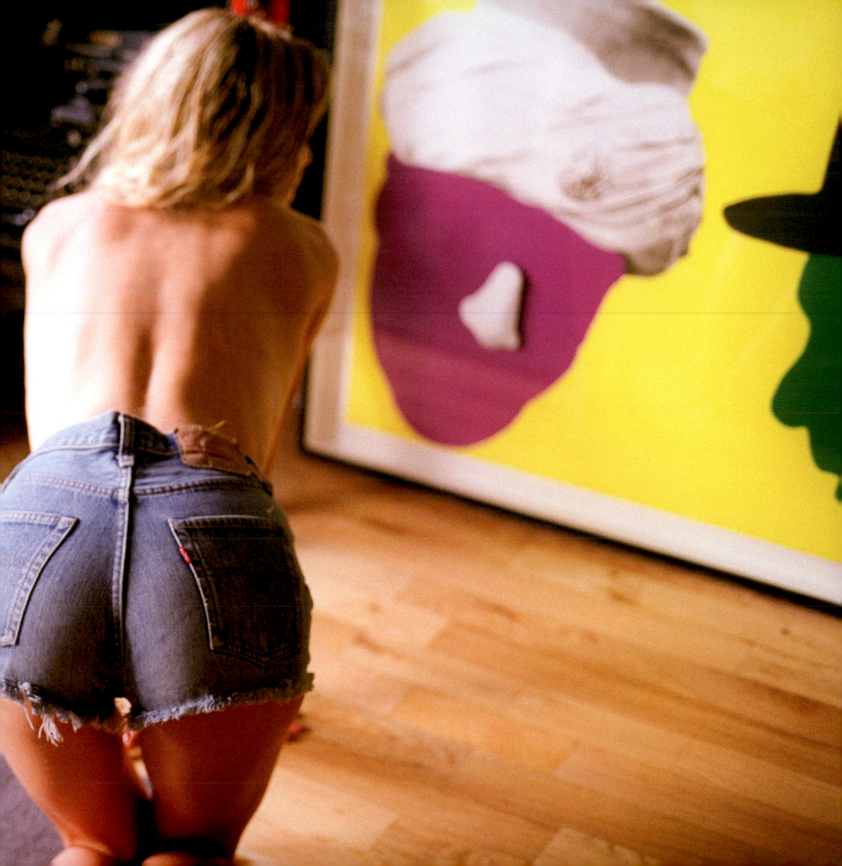

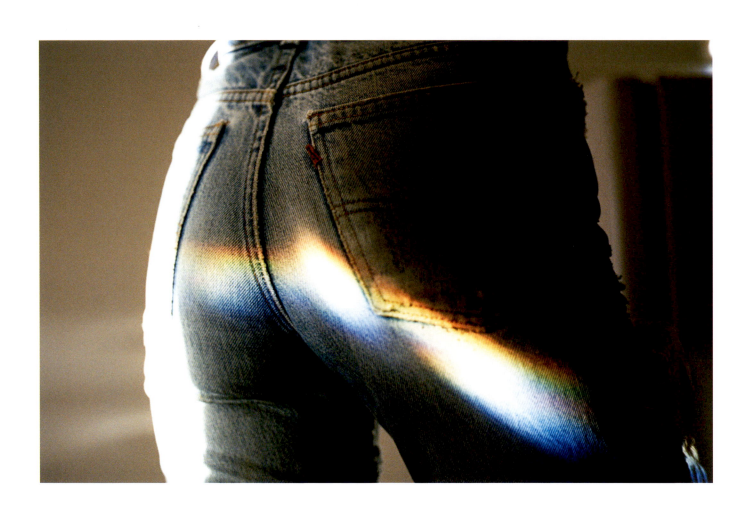

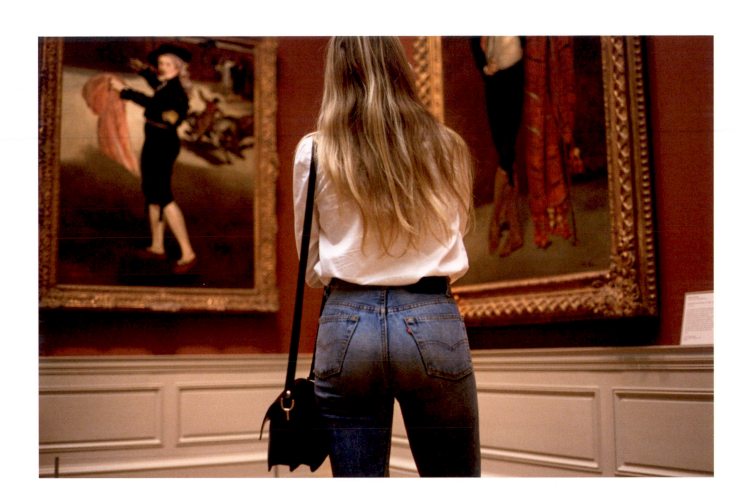

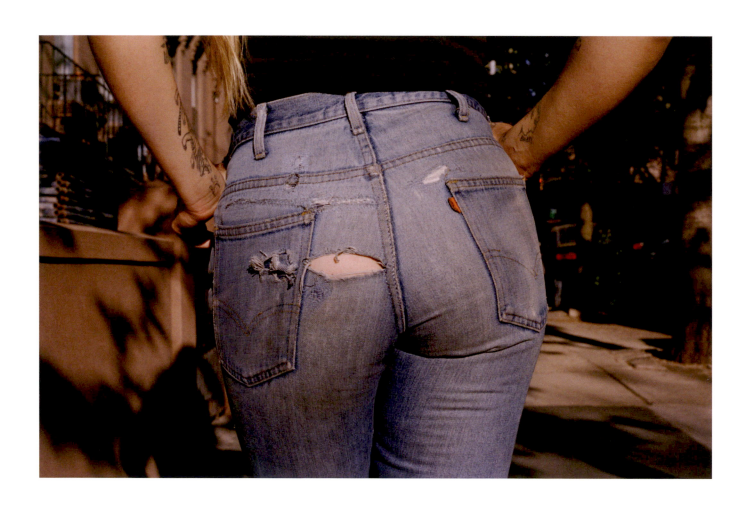

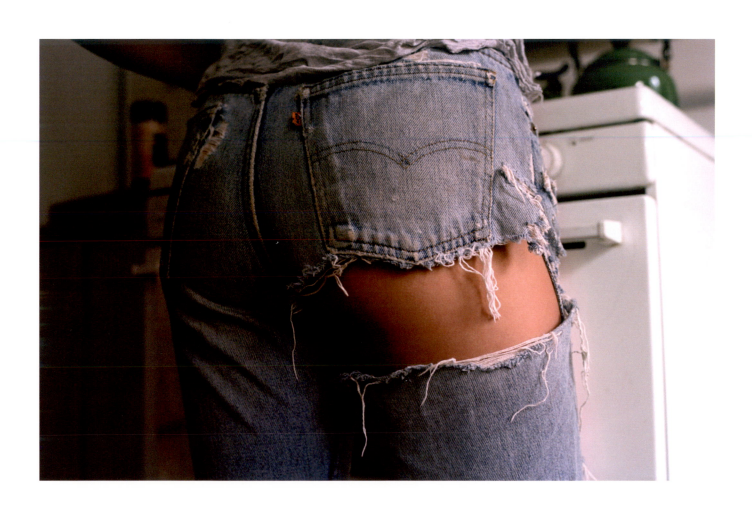

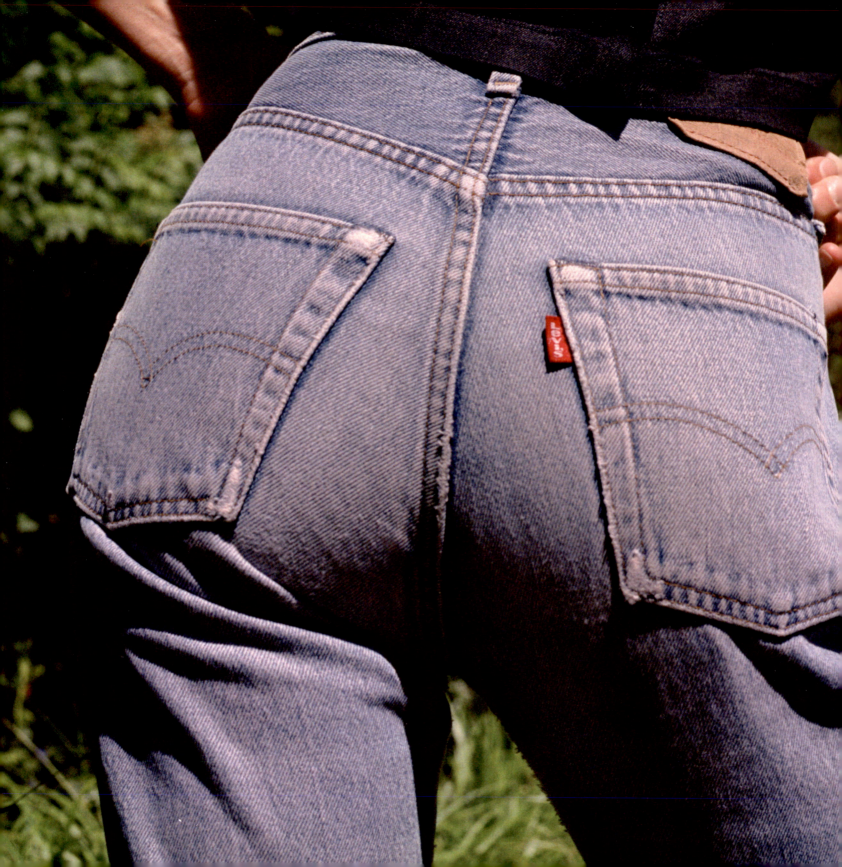

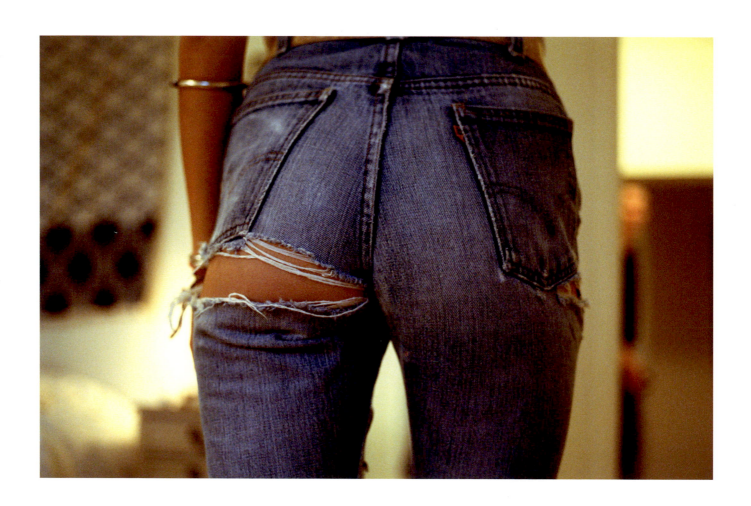

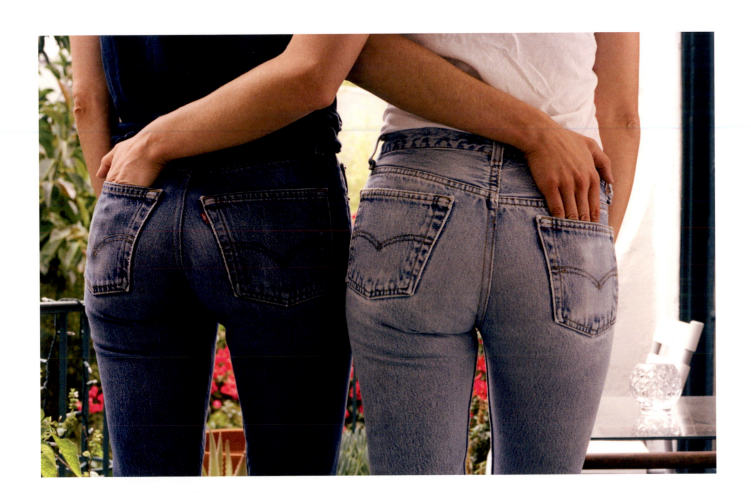

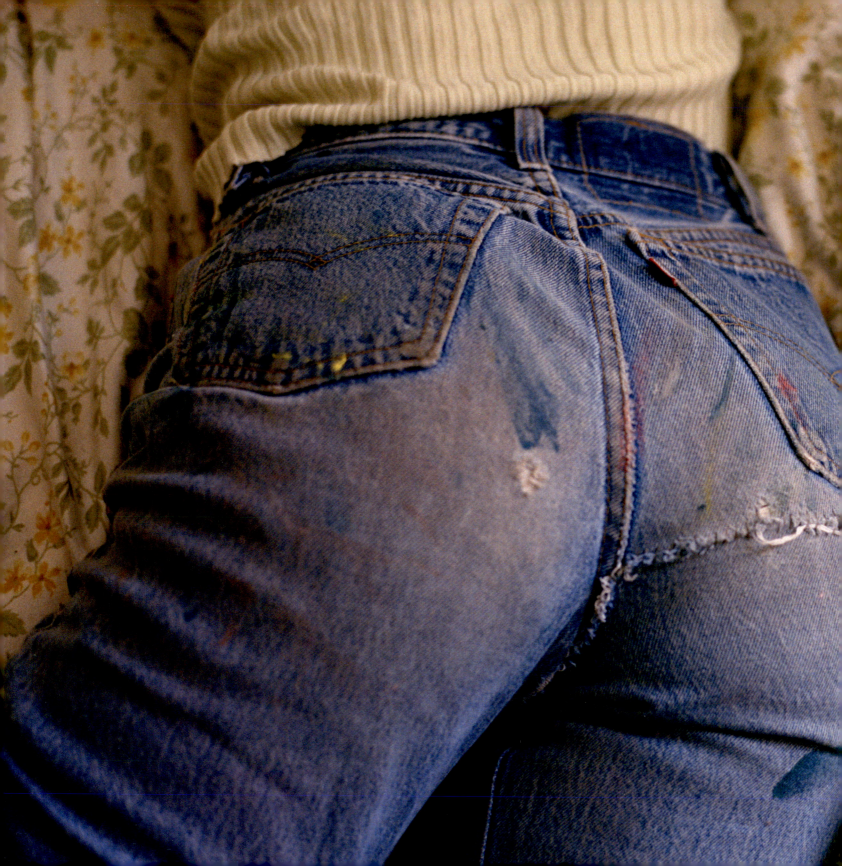

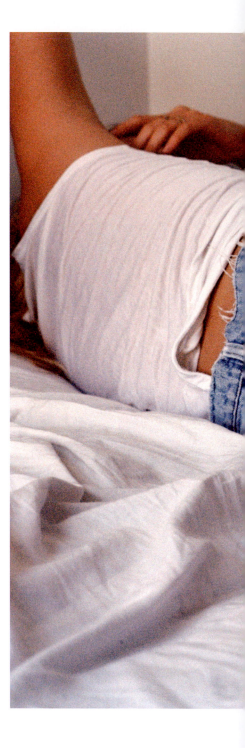

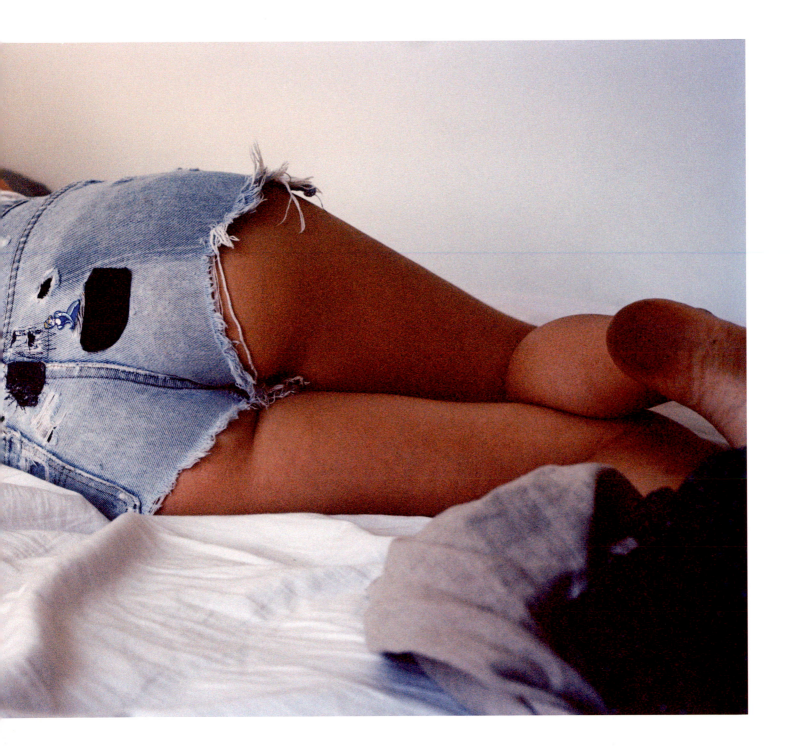

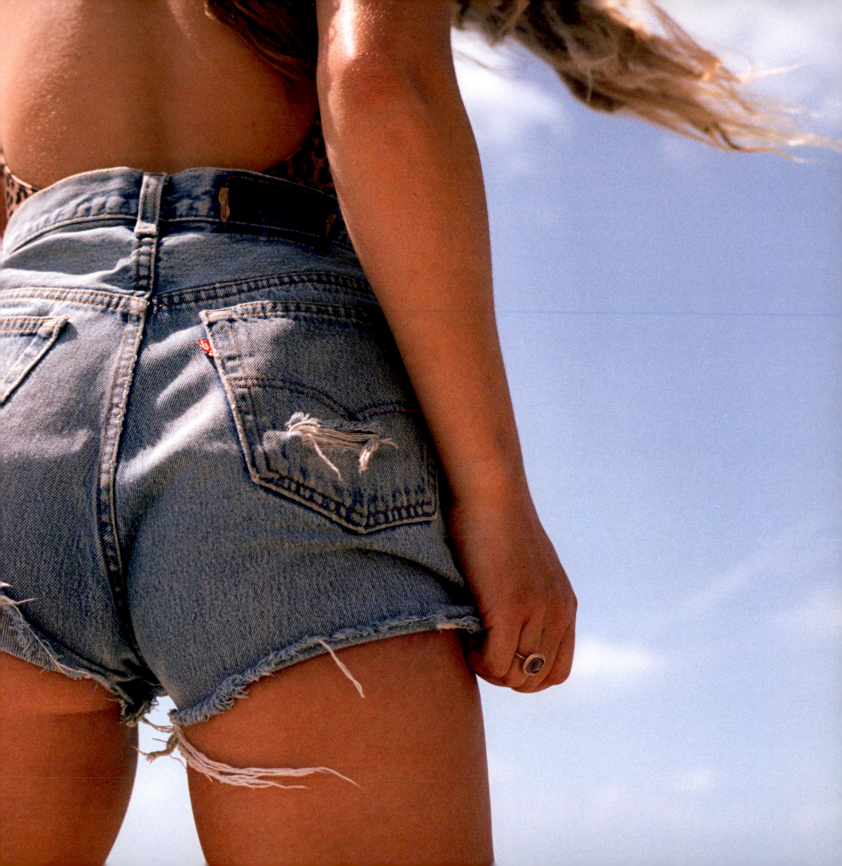

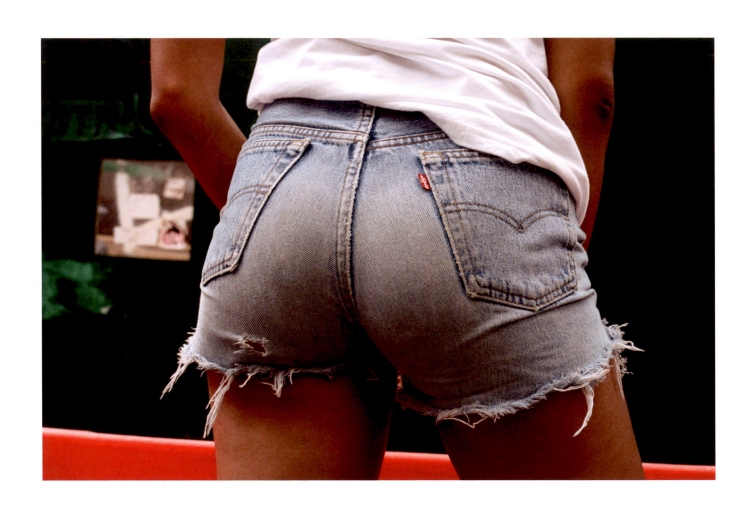

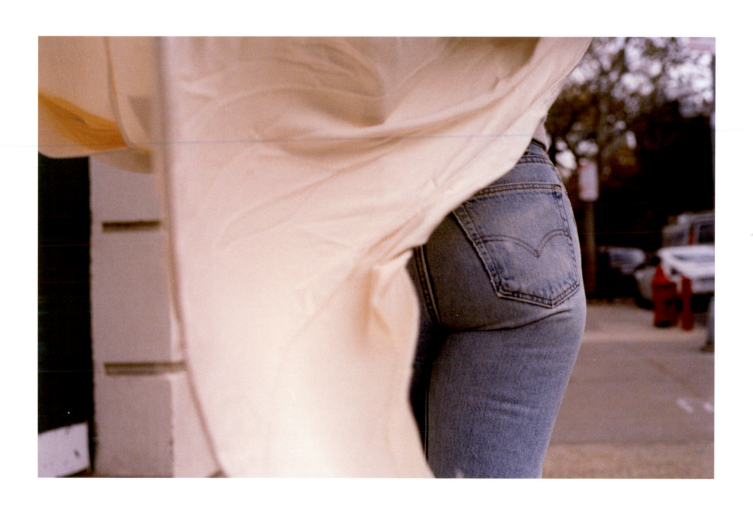

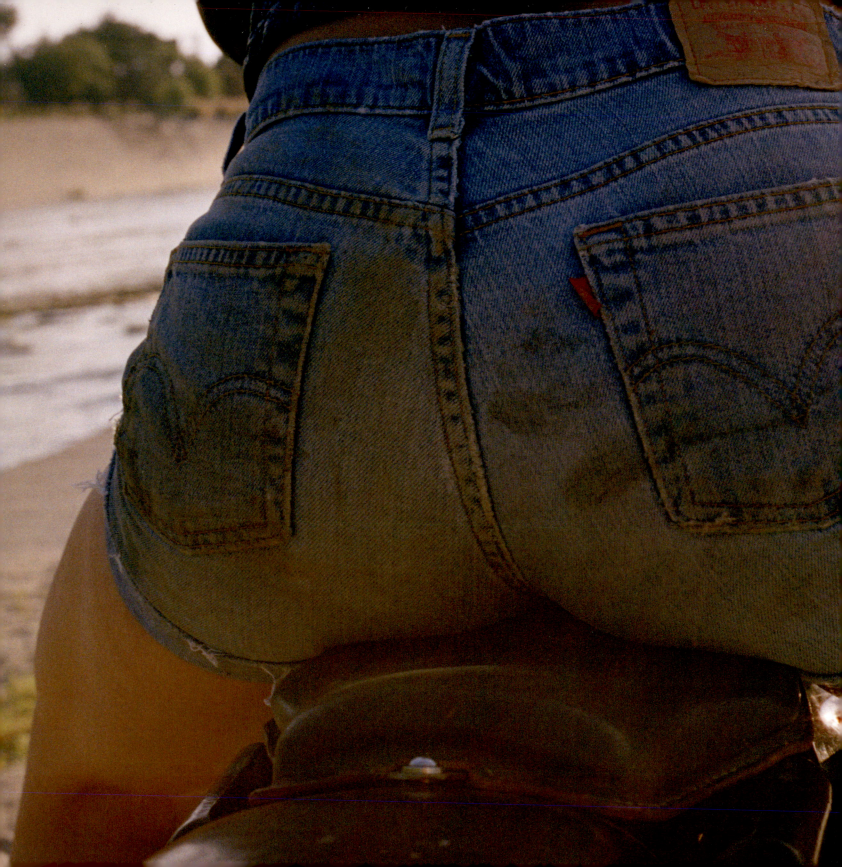

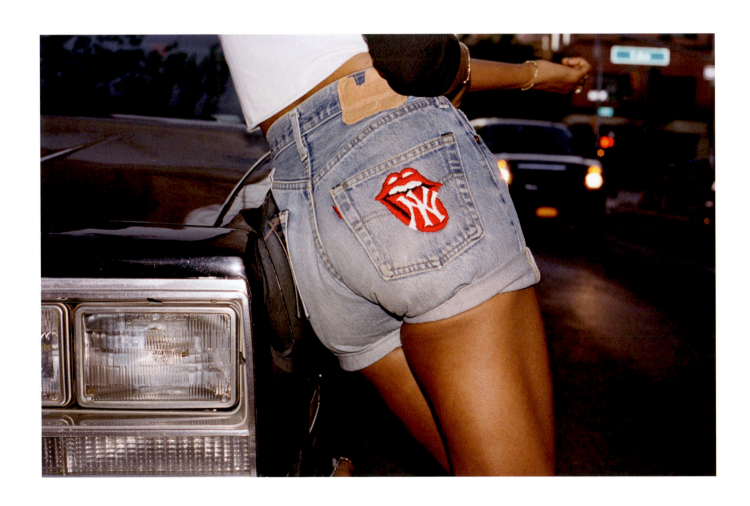

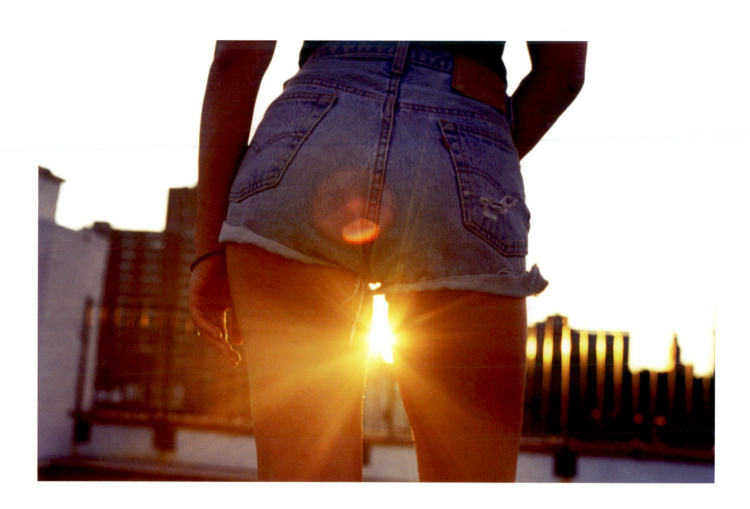

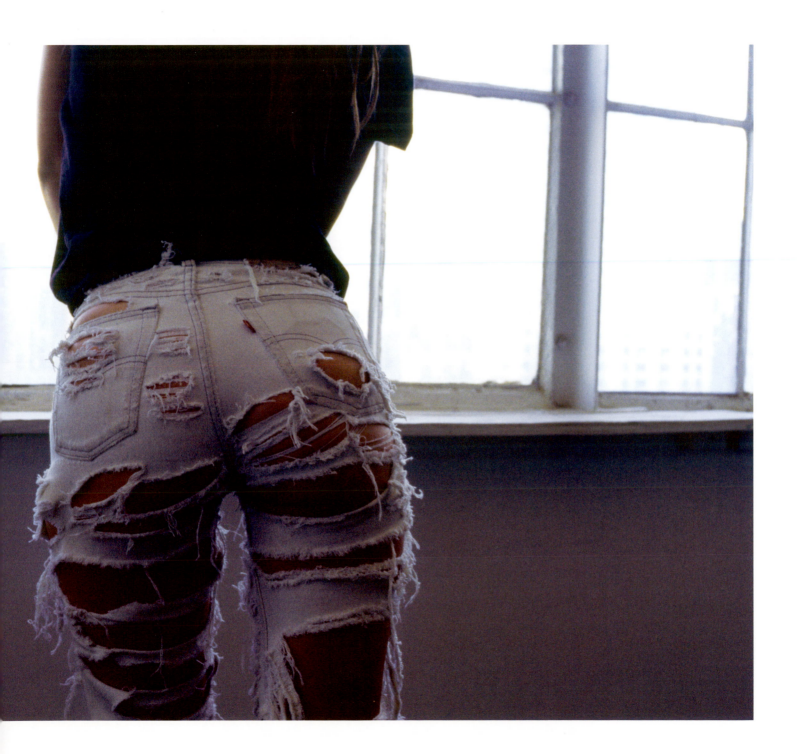

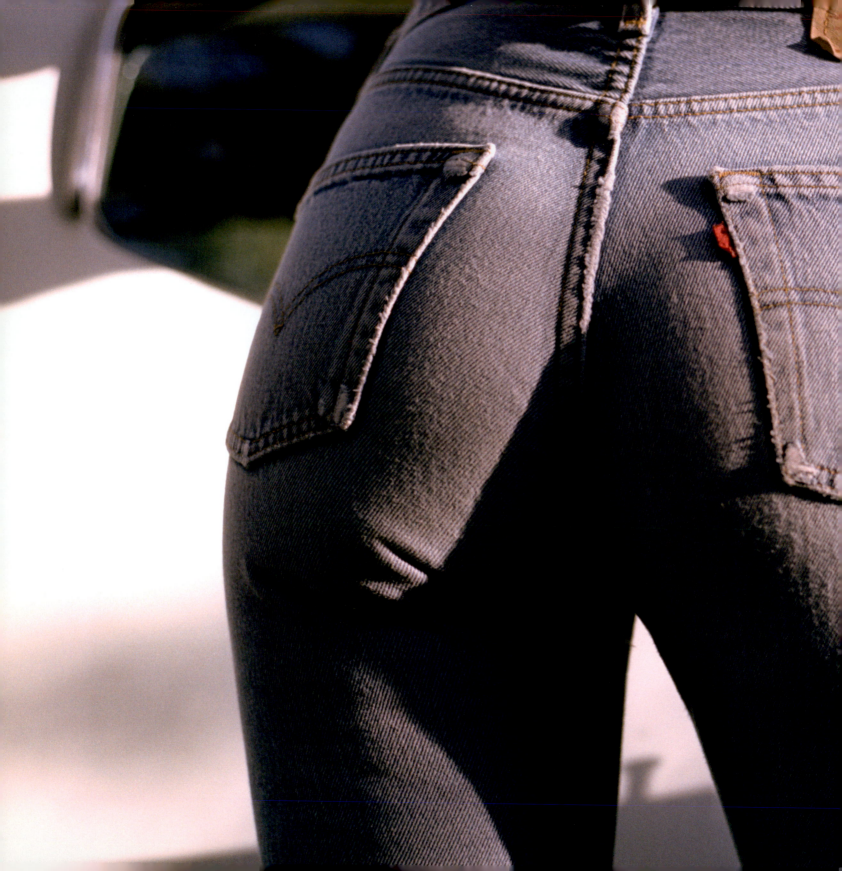

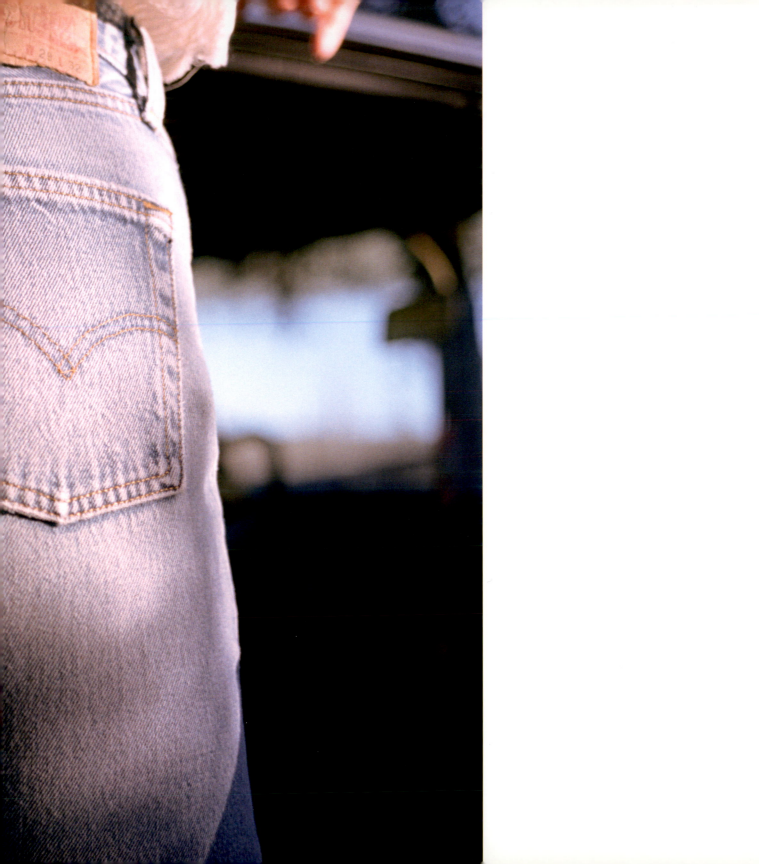

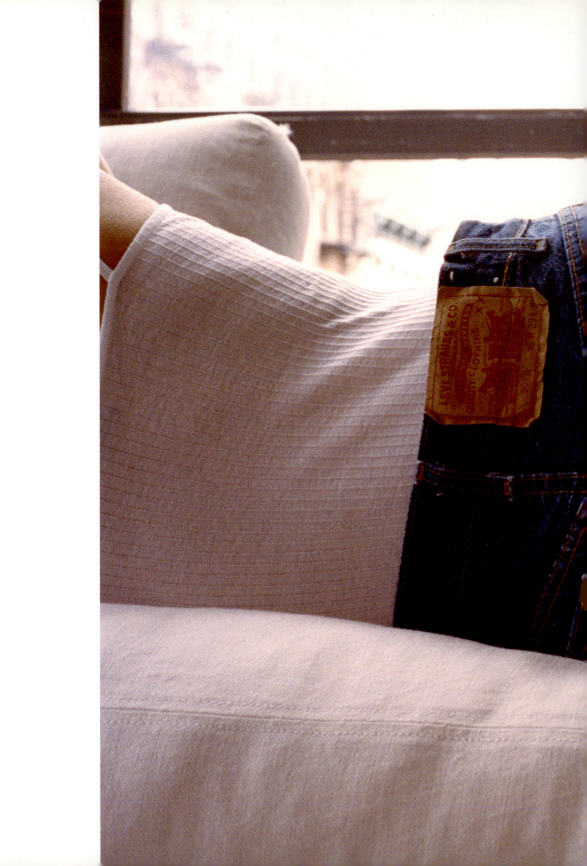

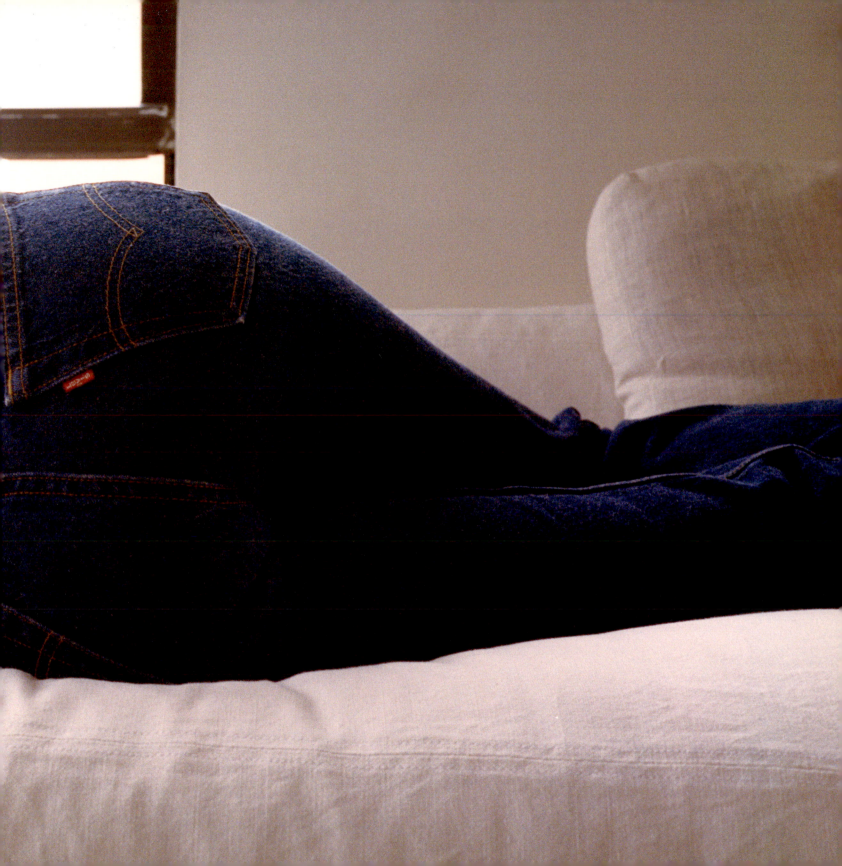

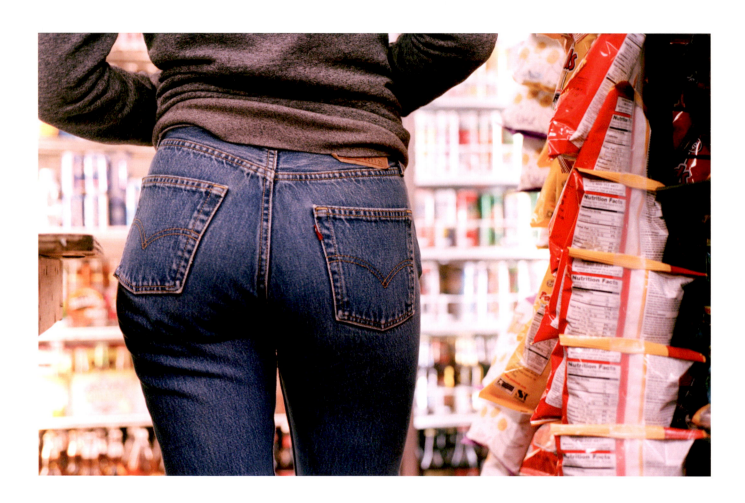

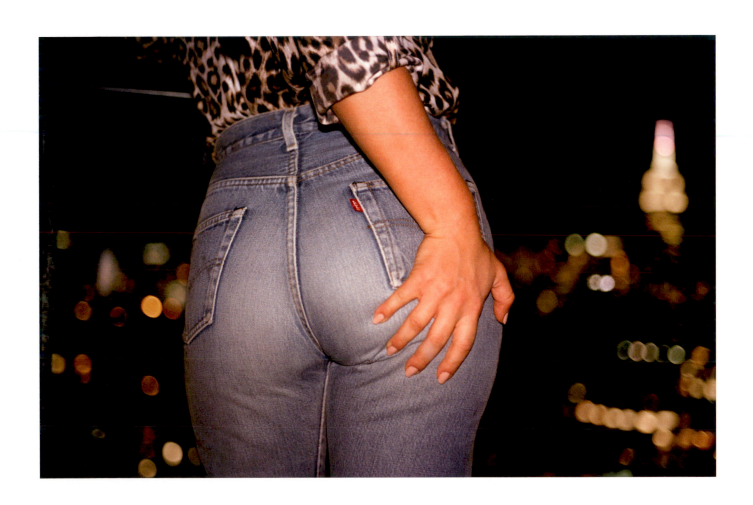

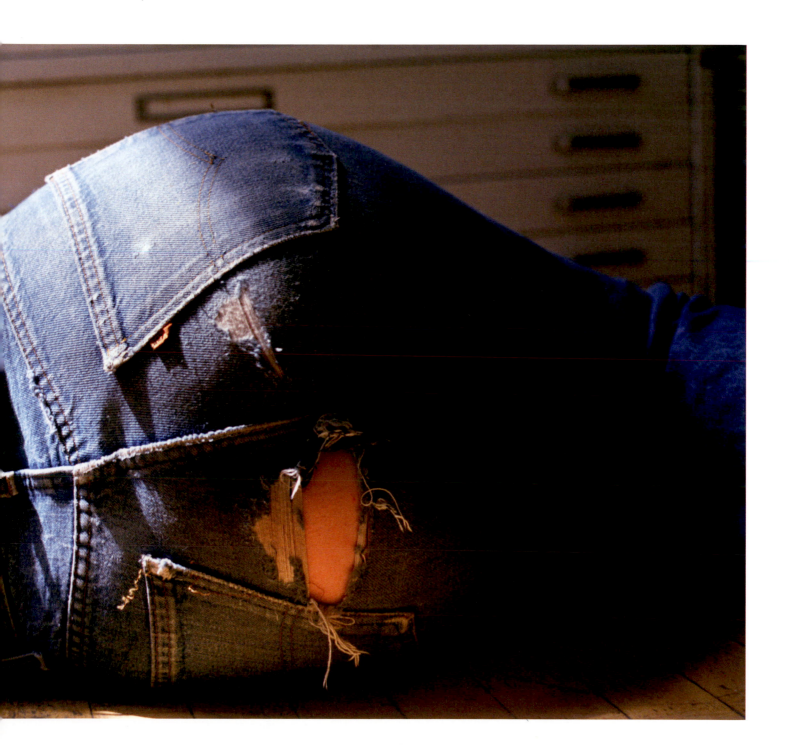

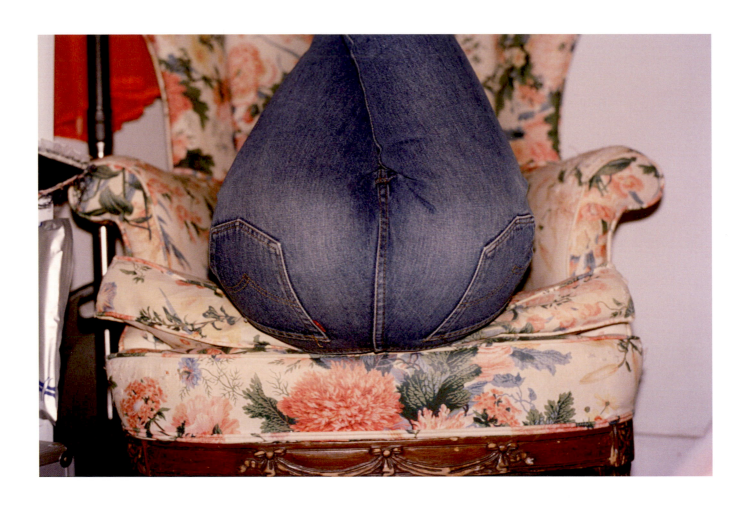

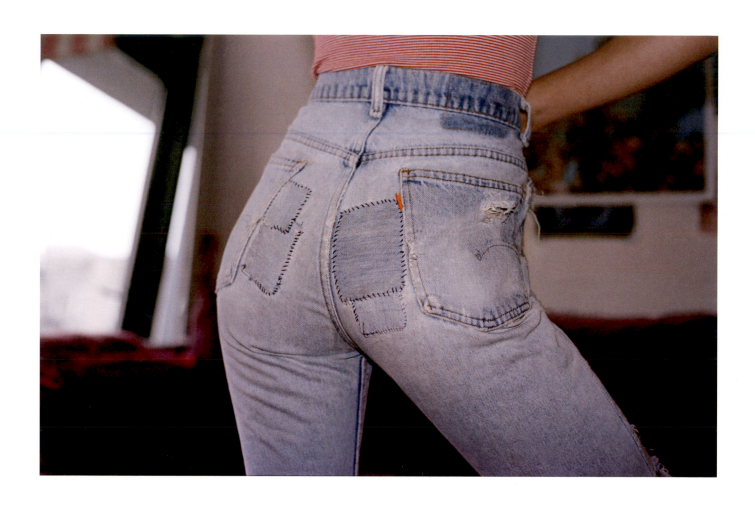

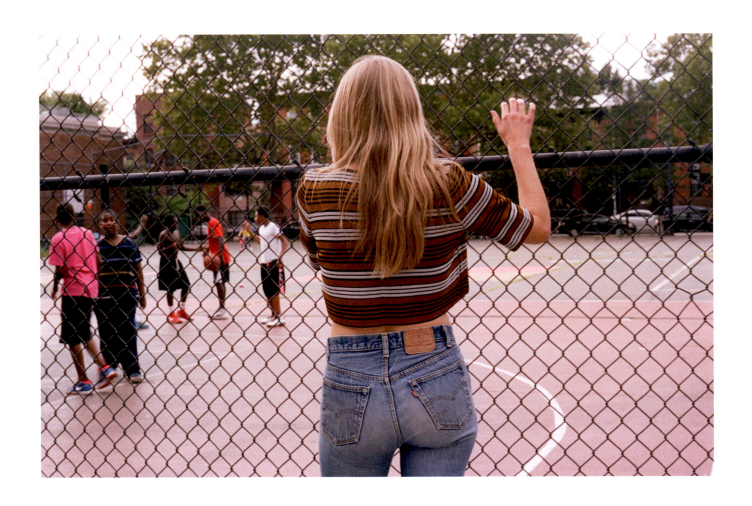

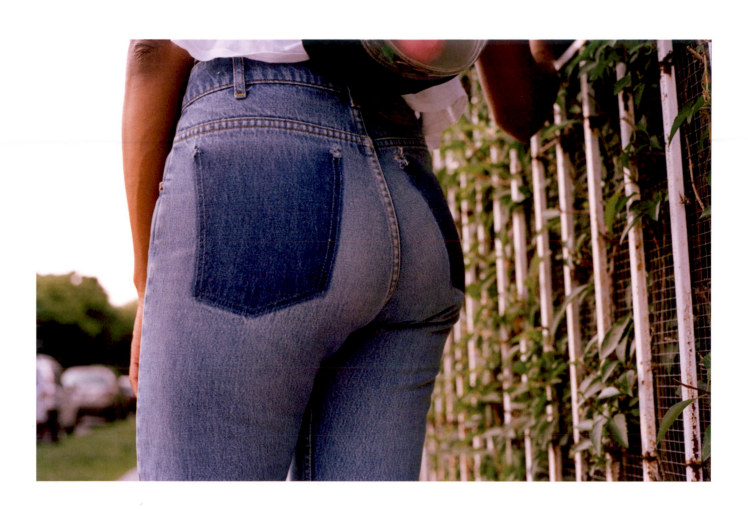

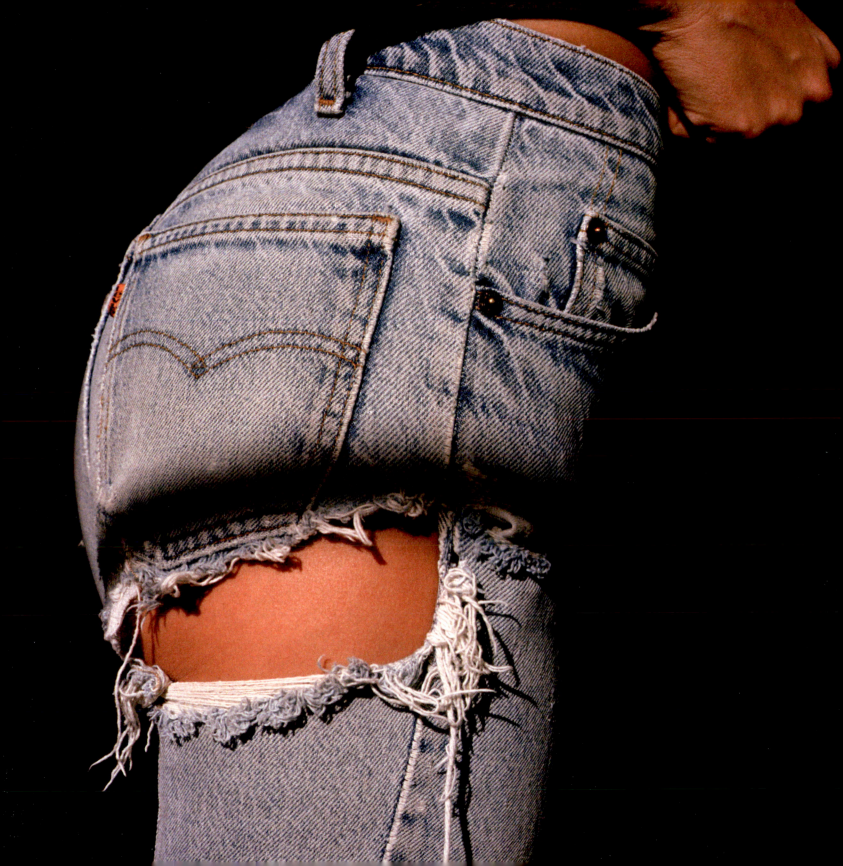

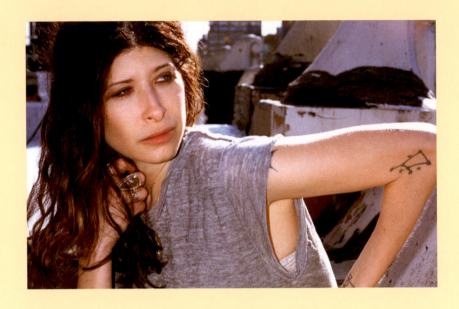

08
Pamela Love
Pam knows how to adorn a woman. Her jewelry is captivating, cool, and adored by many. Here she is, on the rooftop of her studio in midtown.

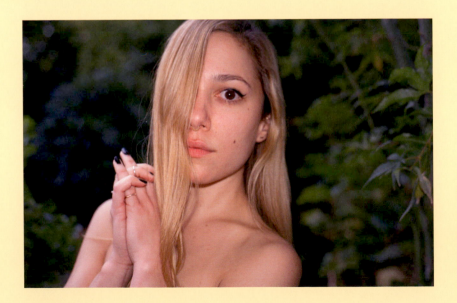

10
Carly Mark
I love Carly; her energy is seductive. She's a fascinating muse for me, an eager adventure partner, and a talented artist. I took this shot in her old backyard in New York, a little zen haven of bamboo trees.

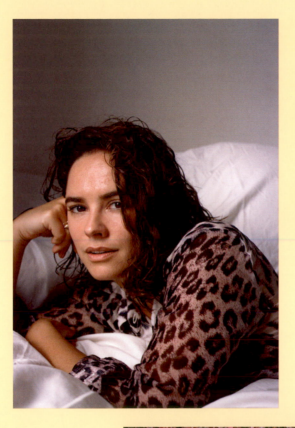

12

Anouk Colantoni
Anouk used to live in a loft a few doors down from me. We instantly became friends. We would spend mornings drinking coffee in the park across the street from our building. A while ago, she moved to a new place and invited me over for dinner. Her doorbell doesn't work, so she has to throw her keys out the window—when I witnessed her doing it for the first time, I knew I had my shot.

13

Georgia Hilmer
We went to the Brooklyn Botanical Gardens. All the cherry blossoms had already fallen to the ground. The air was warm, not yet turning toward summer. When we met, it was T-shirt time, but as we left, you were wanting for a jacket.

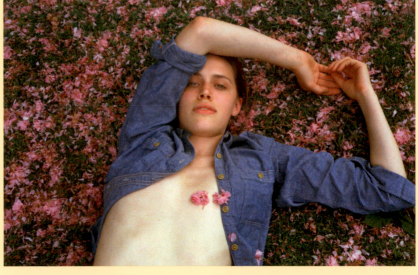

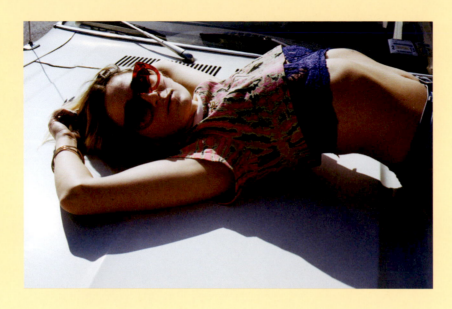

14
Amanda Merten
I was introduced to Amanda through Meghan (page 24). She's interested in photography from all angles: as a subject, as a stylist, and as a photographer. She pushed her jeans to an extreme, which is really not surprising given her penchant for being a badass.

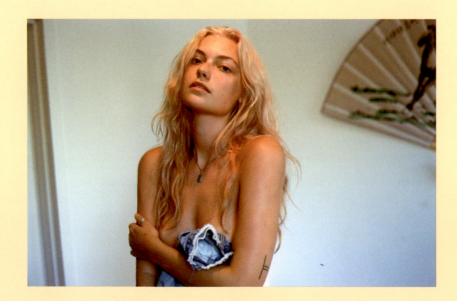

16
Farah Holt
A British fireball, beauty, and wit in one. She's a 90's dream come true, with blonde locks, Doc Martens, baby T's, and—like a cherry on top— a fearless attitude.

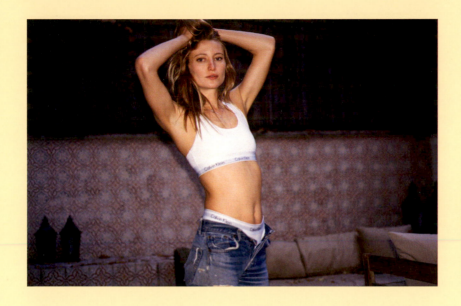

18

Noot Seear
When you are known for being beautiful, it can get to your head. This isn't a problem with Noot. She's one of my favorite subjects—a down-to-earth babe who is always a pleasure to work with and be around.

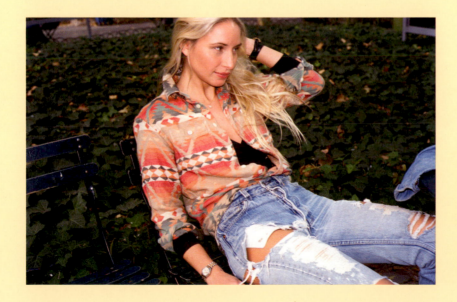

20

Kelly Dunloy
I was going to a party, and Kelly was walking ahead of me in the stairwell, and I said, "OMG, you have to stop." Or more like, please don't stop wearing those jeans, ever. They are completely torn to shreds. It took two years until I saw her again and took her picture with a proper camera.

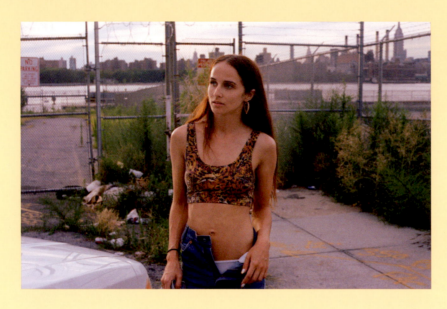

22

Meaghan Mullaney
Meaghan is an American Gothic beauty queen who looks like a ballerina. She is just as comfortable at a shooting range, behind the wheel of her Mustang, or having her nails done. We went on a trip to Nashville once, where we ate Southern food, and at night danced to rave music, dark rave music.

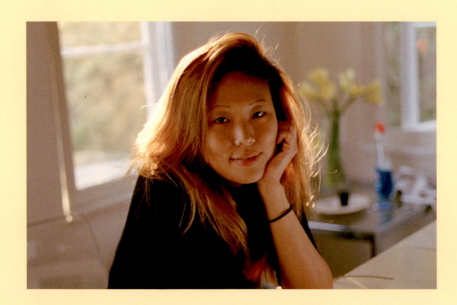

24

Nellie Kim
A bi-coastal beauty, part make-up artist, part writer, and all-around creative babe. I love how she customizes her shorts.

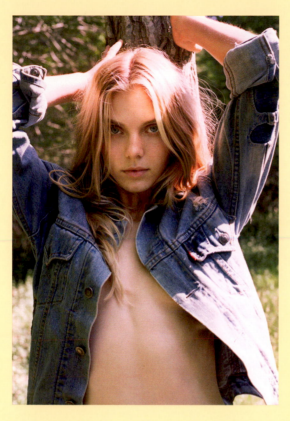

28
Randy Stulberg
Fraggle Rock meets Baby from *Dirty Dancing*—Randy is unequivocal and her energy is electric. She's been a true friend since I first met her in college. I'm blessed to have her in my circle.

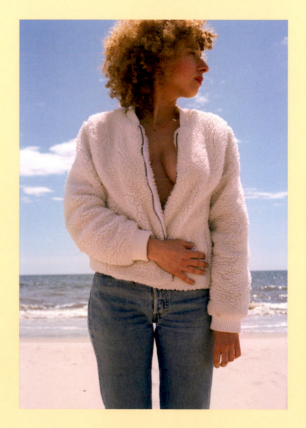

26
Jordy Murray
Jordy reminds me of a unicorn— she's like a magical creature. She ended up wearing my jeans when we shot this on the beach, and that's a pretty good example of what it feels like to hang with her.

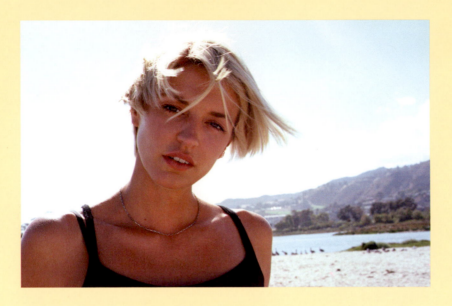

30
Luci Taffs
Getting these shots could
not have been a more SoCal
experience. There were territorial
"locals only" surfers, we were
on this unbelievably beautiful
beach, and Luci had this devil-
may-care attitude about getting
completely soaked in the quest
to photograph sexy denim.
Even the sand can't help but
cling to this tush.

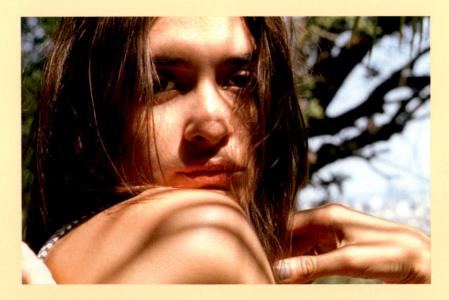

32
Natalia Bonifacci
An Italian flower blooming in
the hills of L.A. When you are
known for being a top model,
the world does not expect
you to position yourself on the
other side of the camera, but
Natalia's curiosity runs deep,
and she creates on both sides—
art directing, editing, and
interviewing when she is not
modeling.

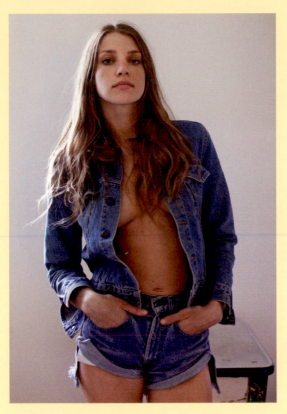

36
Myla DalBesio
We were upstate at our friend's house for the weekend and we decided to go for a walk in a beautiful meadow, picking wildflowers and taking photos. Myla is a collaborator as well as a dear friend. Nothing compromises her ideals or her art, and her mind reflects this.

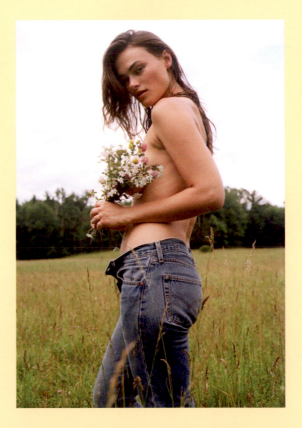

34
Janell Shirtcliff
From the moment we met in a casting studio, I instantly knew this woman was special, but I had no clue that it was to be the beginning of such a meaningful friendship. She is always up for an adventure, whether going off to the desert or jetting to Paris. Hers was the defining first booty.

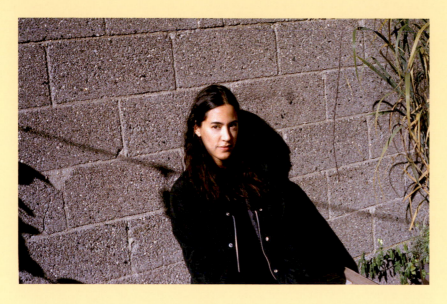

37
Yara Flinn
Yara has an innate understanding of the feminine form—it's a unique talent, reserved for few. I met her by chance in a shop where she was selling her early designs under what sounded, at the time, like a mysterious name—NOMIA—but it's now synonymous with her, and her clothes are on the top of any fashionista's shopping list.

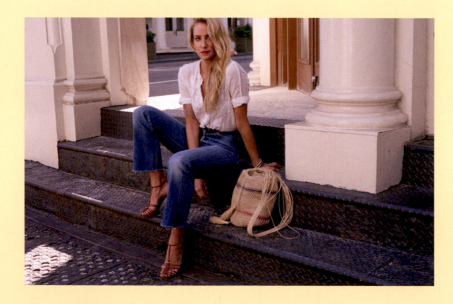

38
Olympia Gayot
Olympia: a woman in possession of perfectly disheveled hair, a well-frayed pair of jeans, and, of course, a stunning pair of heels. She has an immaculate sense of fashion and one of the sweetest hearts.

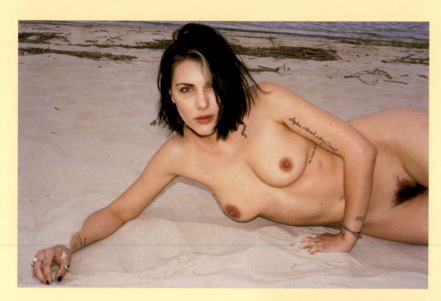

40
Sarah Nicole Prickett
A force of sexual energy and a defender of its place in contemporary art and writing, Sarah Nicole is the founder and editor of Adult Magazine and a prolific writer. Don't mess with her—although the kittens are pretty cute.

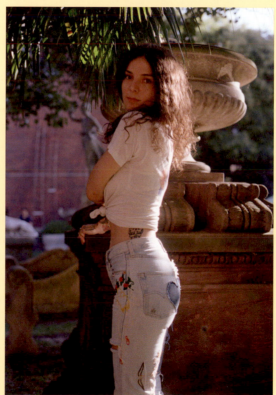

42
Marie-Sophie Lockhart
Marie took her skill at embroidering jeans and created Lockhart Embroidery. Before she was on everybody's radar, I was sitting at Lovely Day with a curator, who fell in love with her at first sight and convinced me to talk to her for him. She was spoken for, but lucky for me, it was a lasting introduction.

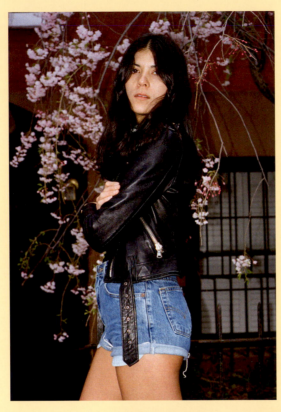

44

Neada Jane Bulseco
Neada is the girl that you notice
from afar—you catch a glimpse
of her hair, a perfect jacket, always
great jeans and shoes, and then
you realize that you know her.
A stunning woman with impeccable
style, she is always a pleasure
to recognize.

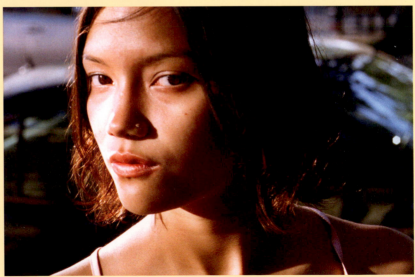

45

Charlotte Carey
I met Charlotte on a dance
floor. She had blue hair
and was surrounded by two
gold-painted statuesque
performers. She was like a
pixie, twirling around them.

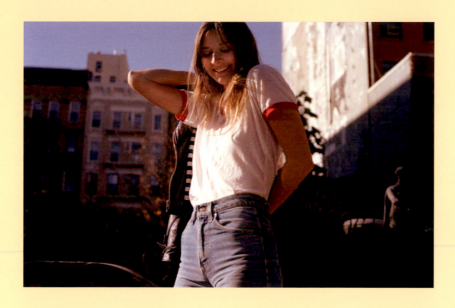

46
Brie Welch
A lover of bottom dollars,
Brie knows what she likes.
The idea of publicly changing
outfits doesn't deter her and
neither does the thought
of having to meet me more
than once in order to get
the perfect shot.

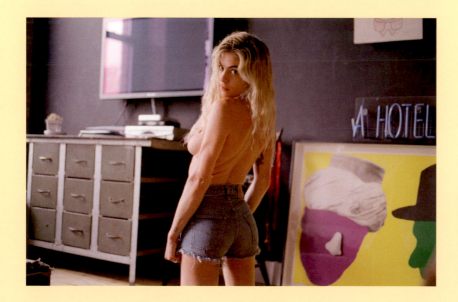

48
Chelsea Leyland
Sweet Chelsea was someone
I shot for an exhibition. In
her apartment, we frolicked
and took some pics of her in
these shorts. These jeans
are perfect. They look like
a work of art on her.

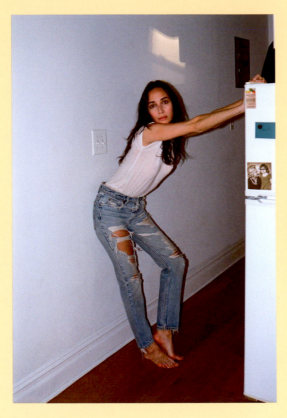

51
Jen Steele
This was shot at the Met, which is fitting for a lady who cares about the arts as much as she does for her fellow girls. An unbelievably sweet person who can't help but give you her full attention when in your presence. The smooth tungsten lighting of the museum only accentuates her glow.

50
Rebecca Dayan
I met Rebecca in a gallery filled with her beautiful paintings. They were portraits, and I was happy to find that a couple of them featured friends of mine. She is a woman of many talents, including acting in one of my favorite movies, *Celeste and Jesse Forever.*

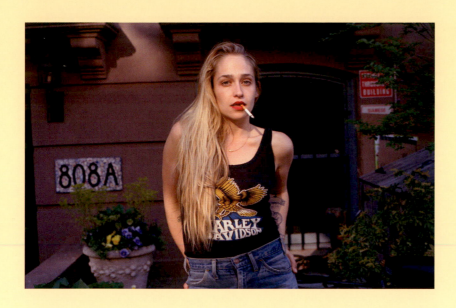

52

Jemima Kirke
Jemima is a true artist. She
has the ability to expose herself
completely to the world with
her art, while maintaining
an intense sense of her own
identity. It's very rare.

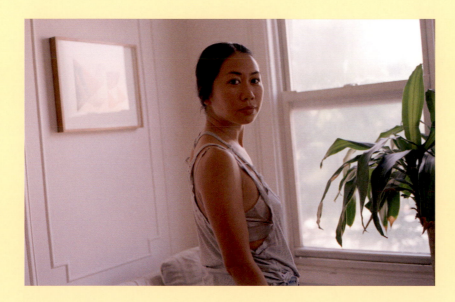

53

Stephanie Tran
You have to be one smart
chick to know how to pull off
a pair of jeans with a giant
tear across the cheeks. Even
smarter to make it look cool
and classy at the same time.
Stephanie can wear anything—
for as long as I can remember
this has been true. We met
right after graduating from
college, but I have a sense that
her style began much earlier.

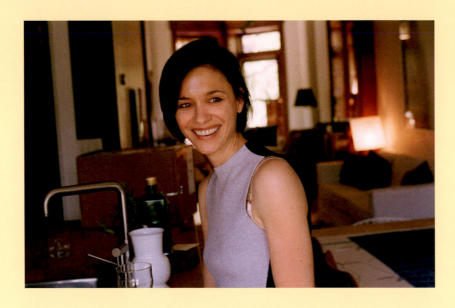

54

Jane Herman
I can't think of another person who is so passionate about denim. Jane says she fell in love with jeans when she sold a pair to Bruce Springsteen, but I think it was a little more fated than that.

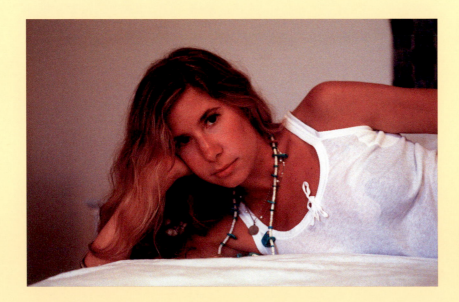

56

Sara Brown
The beauty of shooting on film is later discovering moments that you didn't know were on the roll. Sara's photo was shot at the end of the day, right after a storm, with low light and between shots for her portrait.

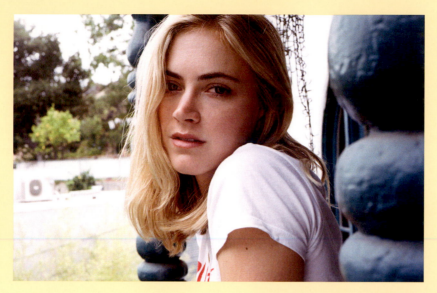

57
Emily Wickersham
Emily's house is in the little village of Hollywood. There is even a miniature Hollywood sign right outside her place. Very fitting for an actress whose head isn't in the clouds. I was late that day, because getting around L.A. can be insane. Her friend Alexa was there too, so I took a picture of them both.

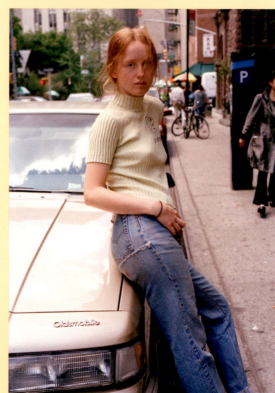

58
India Menuez
India reminds me of a Vermeer painting, with her soft features and classical face. In her own work as an actor and artist, she is wonderfully uninhibited, avant garde. She's a contributor to countless artistic endeavors and a champion of femininity. I find her creativity contagious.

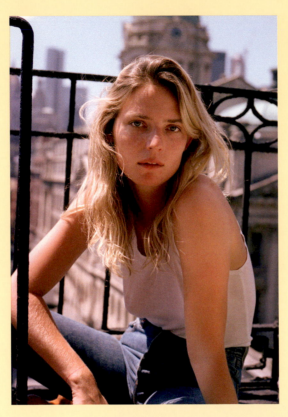

60

Camilla Deterre
We went to a party in the Bronx with a massive dance floor. Camilla's way of dancing— I mean, it's like you've never seen someone dance like this. Part limp leg, part funk queen, I can't explain it—I can only try to photograph her.

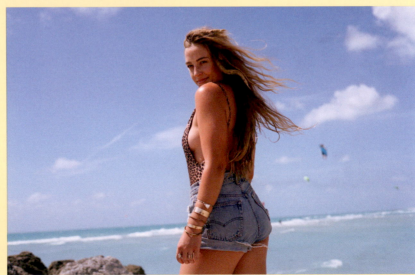

62

Keely Redding
Oh, to be like a little mermaid, frolicking in the warm Floridian waters, not abiding by the rules of land, not having a care in the world. Keely is a mythical creature; the world gives in to her movements.

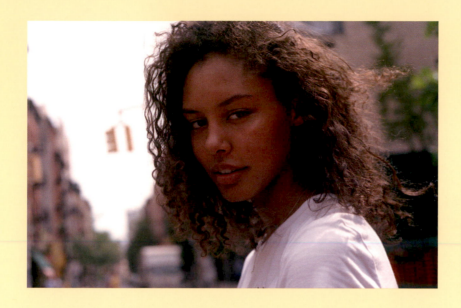

64
Ronja Amanda
Ronja is named after a character in one of my favorite books. It comes from a place of strength and individuality.

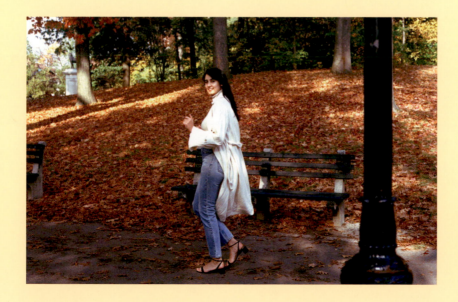

65
Thessaly La Force
A name that sounds like pure poetry. She writes with a sensitivity matched by both strength and edginess. Her fashion sense is killer to boot.

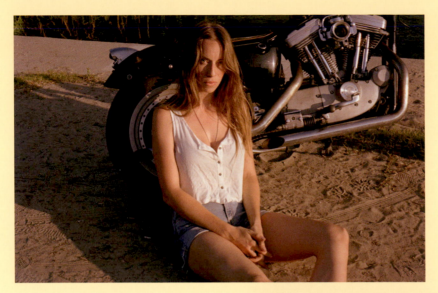

66
Cassandra Wages
She rides a Harley, a real tough cookie. We went on a road trip two years ago and stayed in touch. This was shot by the L.A. River, all the way west, where she lives in a house with chickens in the garden.

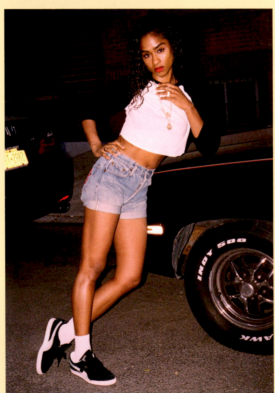

68
Vashtie Kola
She is a Renaissance woman who wears many, many hats... and jeans. The Stones and the Yankees would both be proud.

69
Tracy Alfajora
Having Tracy on board
for any project elevates it
by one hundred percent.
This energetic creature
transforms her surroundings
as well as the beauty in the
world one brush stroke at a
time. I've seen men fall head-
over-heels for her.

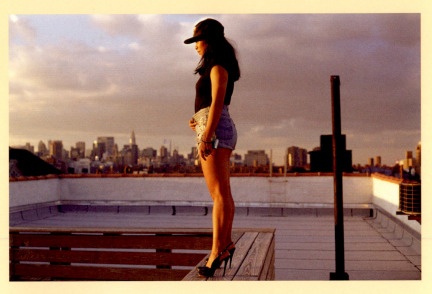

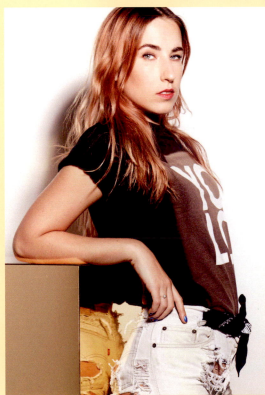

70
Haley Wollens
I'm pretty sure she cut and
sanded these shreds herself
and wore them for me. Haley
is aggressively original and a
natural-born hustler. No one
gets in the way of her vision.

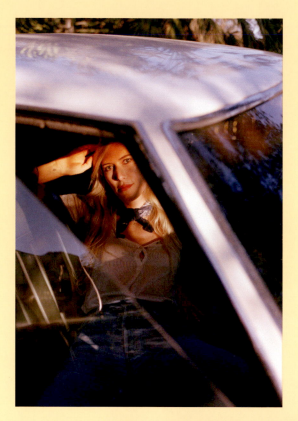

72
Djuna Bel
It is not surprising that
when you're named after an
influential modernist writer,
you turn into a creative force
of your own. Djuna works as
a stylist, looks like a model,
and parties like a dirty old
man.

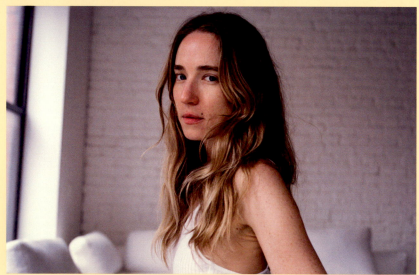

74
Daphne Javitch
Daphne has exquisite style.
It's calculated, but in a good
way. She can wear a vintage
sweatshirt and a pair of jeans
found at the bottom of a pile
of thrift clothes and make it
look incredible.

76
Tizia Sertimer
New York City is a big town, and yet everyone knows everyone—six degrees of separation does not apply here, it's more like one and a half. It wasn't a huge surprise when we realized we had already met a couple of times.

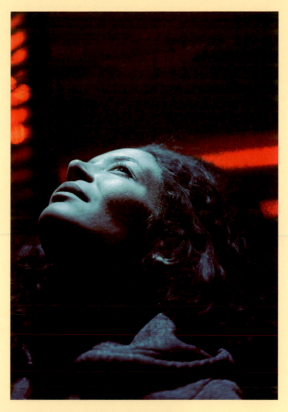

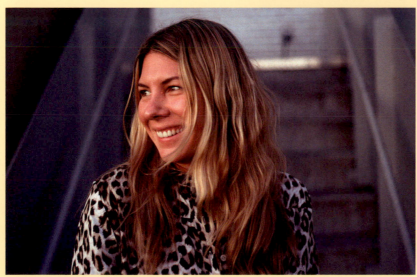

77
Kate Flemming
Challenges slide off her and are left in the dust.

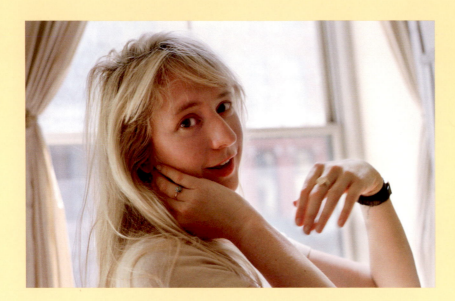

78
Joana Avillez
Her illustrations are just as quirky as she is, and she has an endearing wit. Joana reminds me of a character who walked off the page of a book and into my life.

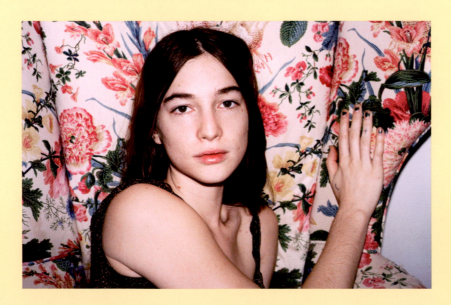

80
Alexandra Marzella
She is an artist whose medium is her existence.

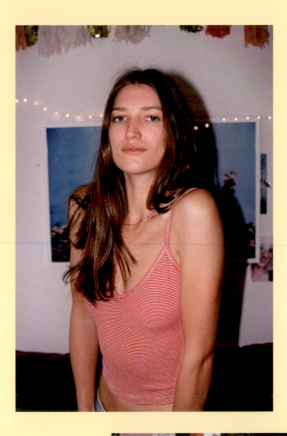

81

Michele Ouellet
Michele's face is the kind on which light loves to linger. It curves gently around her cheekbones and illuminates her large blue eyes. There is a stillness in her face, but her energy is electric—you can sense it in every photo of her.

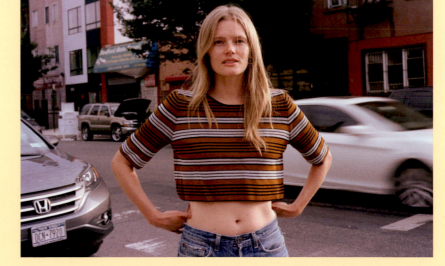

82

Danielle Redman
She jets all around the world, spending more time on the road than at home in Brooklyn. This kind of lifestyle can lead to lofty opinions and a snobbish outlook, but Danielle has always been grounded, a quality I admire.

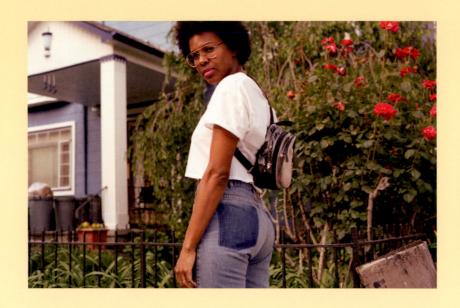

83
DJ Lindsey
As a DJ, she blends styles and genres of music effortlessly, but maybe this is just part of the general attitude that she has towards life. I met her because I was intrigued by the jeans she was wearing, and I introduced myself. They are a perfect mix of vintage and modern.

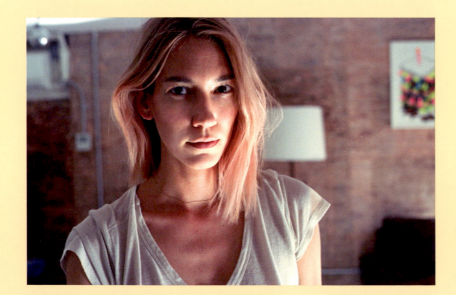

84
Caroline Ventura
I met Caroline when I had to take her portrait. I remember she showed up on set wearing a T-shirt and vintage jeans. Then she showed me her jewelry, which are these beautiful and meticulously crafted gold pieces.

100 Cheeks

All photographs © 2016 Kava Gorna

I would like to thank all the women
that participated in this project and
supported it along the way.

Sweet thanks to Jake Begin for his
endless care and encouragement.

Thank you to Ewa Gorna, Miroslaw Gorny,
Luxlab, Carl Saytor, Matt Wright,
Brian Awitan, Brandon Harman,
Brendan Dugan, Leah Bank, Alexa Jacobs,
Caroline Ventura, Piera Gelardi,
Teddy Wiloughby, John Parker Argote,
Piotr Uklanski and Jessica Craig-Martin.

Art Direction: Kyra Griffin
Design: Caroline Askew
Production: Bettina Sorg

Printed by Shapco

ISBN: 978-0-692-68818-2